All the Single Ladies:

Reflections on Singleness from the Unmarried Women of the Bible

Krystle D. Hunter

ISBN: 978-0-578-83112-1

DEDICATION

To all the single ladies tired of being called to the dance floor at your homegirl's wedding. I'm sick of it too, sis. Be encouraged; there's a new song getting ready to call you onto the dance floor.

&

To my spiritual mother, Tayana Holland: Thanks for cheering me on and teaching me to slow down and enjoy the ride.

CONTENTS

INTRODUCTION

Hey Sis, lean in... there's something I want to share with you. Did you know that singleness is actually God's idea? I know, I know. This is not just another book about singleness. I promise you, this one is going to be different.

You see, I've learned in the last few years that singleness is just as holy and ordained as marriage is. If you're a young, single, Christian woman, you know that singleness is not as appreciated as marriage is. The world either puts you in the "single and lonely, woe is me" pity party, or consider you to be living reckless and sowing your "wild oats"…whatever those are. It's one thing for the world not to use singles as either a pity party or complete chaos and wild. But what about the role that the modern-day church plays in this? Even in the church full of individuals from varying walks of life, it seems like the only relationship status discussed and invested in is marriage. We've got some work to do! This is the reason why I wrote this book.

Singleness is a God idea, just like marriage and family. The state or season of singleness wasn't an afterthought of God. And because God is sovereign, neither is it happenstance. You see, you're not single because there are no good men left. Insert praise right here, if, in fact, you are still waiting on God to send and reveal your husband. #PutAPraiseOnIt. You're not single because there's something wrong with you or even because you're not ready for marriage.

For all of mankind, there is an appointed time for singleness. This is the way God planned from the beginning of time. Some may not like what I'm getting ready to say, but I've got to say it. Preparing for marriage is not the sole definitive purpose of our singleness. There will be people who get married and people who don't get married in their entire breadth of life. Some will marry young, some will marry later in life, and some may never marry according to their choice and God's plan or the purpose of their life. So how then should one's only goal in singleness be to prepare for marriage? It doesn't make sense.

I struggled with this for much of my twenties into my mid-thirties. The messaging I received from the church had me thinking that singleness was all about marriage. This was made especially clear when I was the target of the well-intended congregation and clergy who said things like, "Oh baby, you're not ready yet" or "keep on working and serving, and Boaz will come." Though many only meant to encourage me, these words began to eat away at some of the best years of my young adult life.

I put my everything into studying and preparing to be somebody's wife. Every seminar, book, conference, prayer shawl, and more was me showing God that I was "ready." I nearly memorized the books of Esther and Ruth as my "how to get a husband" manual. And you know what... I was still S-I-N-G-L-E. Hello? May I speak to customer service?? I'd like to return all of it...all the products, all the t-shirts, all the tears cried, all the lonely nights and all the "faith" I had put into this faulty product.

But before I gathered my receipts to return this stuff, I asked God one more time to give me the steps or an example of who to follow so I would finally be ready to marry my husband. What God did next is the reason why you are reading this book today.

Many single Christian women are most overwhelmed by the unrequited love of their mystery husband. Why does life get hard and depressing for so many single ladies when there is no man around? I posed this question to myself, my friends, and my pastors many times in different ways. Truthfully, I kinda got sick and tired of only hearing about Esther meeting her king and Ruth working in the vineyard when her Boaz found her. Sitting in every single conference and workshop, I had grown very bitter and deaf to any message about single women from the pulpit. I was sick of it. I said that's great and all, but me and my girls are still single. So, what are we gonna do? Then it dawned on me: I was brainwashed. I was tricked. I was bamboozled. The value placed on marriage was greater than that of singleness.

Marriage, a wedding, and a man had become the goal of my entire life and I was suffering hopelessly on the inside. Think about it. How often do our minds and emotions suffer because we feel like something is missing without a husband? Whether it's taking out the trash, filling up your gas tank, a valentine, thunderstorms, going to weddings, baby showers, eating out, the marriage retreat at church, or every single holiday family gathering you can think of... not having a husband (or at least a prospect) is uber stressful for us. And it's not only at that moment, but the loneliness and emptiness have a way of inviting themselves into some of our happiest life experiences as well. Our emotions go from Zero to negative 99 in about as much time as it takes to get a mani-pedi.

In a quest to be free from this torture -because that's precisely what it was- I started seeking revelation and wisdom from the women in the Bible that successfully navigated what I was experiencing. Don't get me wrong, I love Esther. Ruth is my girl too. Sarah, Hannah, Mary, and Elizabeth all get major points with me. I've learned so much from them all. But the truth is, I was discouraged reading their stories, following their plan to a tee, and still not having the outcome they received. I needed to know what to do now as a single woman. This led me to the stories of single women in the Bible.

In *All The Single Ladies* I have the awesome privilege to introduce or reintroduce to you some of these women. It's a casual conversation with my sister friends. That's you. There will be moments in this book where you'll need to skip around chapters or "get stuck" in a particular chapter, depending on how God speaks to

you. For this reason, I've included some reflection questions, prayers, and worship songs to allow God to minister to you. Do what you need to do to hear God's voice, remember His promises, and encourage yourself in Him.

At the beginning of each chapter, you will see the scripture referenced for the respective lady. Be sure to check out those scriptures for yourself. The Bible, even the small excerpts of these women's stories, are way better than my book! I'm only sharing what God has spoken to me from these scriptures. I recommend starting with the Bible stories to gain some context and backstory about the women. Even if you're familiar with the story, pause, pick up your Bible, and reread it. You just might see something brand new that you've never noticed before.

After reading the Biblical account and the corresponding chapter in the book, you can mull it over with reflection, worship, and prayer. You may even want to highlight, doodle, or flag words that God impresses upon you. Whatever you do, do not feel pressured to read All the Single Ladies from cover to cover. If you do, that's okay, and if you don't, that's okay as well. Each of these features is designed to meet you right where you are. That means from your perfect days of sunshine to your days when it seems like you have your very own personal rain cloud. I'm praying that this book will be an encouragement, a shoulder to cry on, a tissue to wipe tears, a smile to cheer you up, and like a great pair of jeans that give you that extra spring in your step.

This book took some years to complete I was embarrassed, ashamed, and fearful to share my story, but I believe that it's right on time. God has healed me through this work, and I hope there's a glimmer of hope in it for you as well. It was vital for me to author a book that is different from other books marketed to single Christian woman. My prayer is that I've succeeded in this quest. Depending on how long you will be unmarried, you can start to hear the same messages repeatedly. So much so that you begin to ignore and tune out anything with the word "Singles' Ministry" attached to it. I'm thinking you may have even googled "singles' ministry books" and perhaps my book was somewhere on the list. Although I'm elated that you decided to move forward, I want you to know that this book has been fought by the enemy. What you're getting ready to read will challenge you and make you a bit uncomfortable, which is exactly where God wants you to be for His plans, purposes, and glory.

For this reason, I'd like to share with you what this book is not.

This book will not:

● Bash men and deny their necessity and significance in God's plan for the Earth.

● Allow you to wallow in self-pity, rejection, and defect.
● Diminish and dismiss your desire for love, marriage, and companionship.
● Present a fabricated/false/fake happiness as a #SingleLifeRocks platform.

- Layout a 3-5-7 step plan to "cure" your singleness and be found by your husband.
- Promote a spirit of jealousy or envy towards married women in your life.

This book will ignite something different for each reader. You may laugh, cry, ponder, and even frown. I encourage you to take all those emotions in and put them before God.

If you're reading in a book club, create a safe space for women to share candidly about what God is doing in their lives. If you're reading this book solo, then I invite you to welcome someone else along the journey. God created us for relationship; we were never meant to do life alone. Call up a sister-friend and take this journey together.

However, if your choice is to have an intimate connection with Jesus, then by all means, grab a table for one and let the ride begin.

Now put your hands up... let's pray.

Worship
"Psalm 23"- *by Nathaniel Coe, III & Somer Jordan*

Prayer

Father God,

Thank you for my sister, who is reading this book. Nothing in this life is by chance, luck, or coincidence. You knew this moment in time would happen. So Father, I ask that you open up my sister's heart to receive you as she journeys through this book. Whatever she is in need of in this season of her life, I believe that it is being released and that it is within her means to obtain it. May she experience restoration for her soul, hope for her future, protection for her present, and healing from her past in Jesus' Name.

2 ABISHAG
I Kings 1:1-4

I must be crazy.
He's old... eh, he's powerful.
Wait! Am I what they call a gold digger?
Excuse me, You want me to what?
Naked? What's the catch? What's in it for me? I can, and I
should be doing better than this.

If you've ever glanced at the story of Abishag, I'm pretty sure it would be difficult to identify with this woman in any way. That's precisely why she's our first character to study. There's something to be said for a faithfully obedient woman. In a society where commitment is taboo, and rebellion is celebrated, Abishag's maturity as a single woman is noteworthy.

Abishag wasn't just some random woman in the community. As we look at the scripture, we find that Abishag was sought after. King David was falling ill,

and his physicians prescribed another woman to cure his ailments. What's interesting is that King David was notorious for his hundreds of concubines. Though it was permissible in that day, I mean really, David, how many women do you really need? I digress.

Well, here's lesson number one: What would you say if I were to ask you: What makes you special? What makes you unique? What makes people go out to look for what you have? What do you possess? What do you bring to the table?

Let's be clear here, Abishag was not a King David groupie, waiting outside of the temple. She wasn't throwing herself at his servants and plotting ways to "run into them." Yet, King David's servants set up their personal Miss America pageant, and they found her. Can you imagine what the conversation was like to get Abishag to agree to the job title of "Royal Bed Warmer?" Think about it, the country's most (and I mean the most) physically beautiful woman, who's pure, responsible, and mature enough to handle such a request, is approached by royal officials. I mean it's not like David was in the young King David phase that all the women once desired. He wasn't. By this time, David was O-L-D. So old that he was bed stricken, always cold and losing his life minute by minute. Abishag was brought in because the officials felt that her beauty and vitality would extend and save David's life. Wow! What a responsibility. You want me to "revive" the king? That's a heck of a job interview. Nevertheless, for some unknown reason, Abishag accepted the position.

She was brought to the king and got to work.

Faithfully, she would lay with King David to keep him warm. This was not a sexual relationship at all. Some probably talked about Abishag. Questioning her purity, motives, and sanity. But at this point, the joke is on them. Can you imagine the wisdom, insight, and royal knowledge she was made privy to? I mean, they weren't having sex because he had concubines for that. There were no Facebook and Instagram notifications to check into "the bed" letting followers know her status had changed.

We can infer that there was a lot of nurturing, conversing, and natural chemistry that went on here. Abishag was fulfilling her assignment. She was working. She was serving with her beauty, character, and heart. Didn't matter that David was old, possibly dull, and dying with each passing day. All that mattered was that she had been called to this position, and she served it with everything she had. On paper, it seems as though this is a small meaningless role. All she had to do was keep the bed warm and comfortable. Easy as pie. Probably could do it with her eyes closed. Just look at the impact she had by being attentive to her duties.

Eventually, King David dies, King Solomon becomes his successor, and Adonijah is found chasing after Abishag. This is all we know about Abishag. Abishag was so favorable that Adonijah, King David's son, wanted her for himself. He asked his brother, King Solomon, for her hand in her marriage. From her service, Abishag was so desired that Solomon compared her to his entire kingdom. Whoa!

Clearly, there is a glaring principle that we can learn

from Abishag. Be faithful in whatever position God has placed you in. Now, this is a broad statement, but it literally applies to every aspect of our life.

Imagine that life was just an average life for you. You had all the basics: family, food, shelter, etc. You go to work, nothing cool like Secret Service or Astronaut, but you work. Subconsciously, we work our positions in "average mode" vs. "awesome mode."

Before we dive into what it means to be faithful, it's important to note that a God-given or kingdom position and elevation comes when we are obedient to Christ and have humility. The Living Bible translation says in 1 Peter 5:6:

"6If you will humble yourselves under the mighty hand of God, in his good time, he will lift you up. 7Let him have all your worries and cares, for he is always thinking about you and watching everything that concerns you."

I recently learned that this was an area of struggle for me. One day the Holy Spirit prompted me to pray that I recognize false humility and desire genuine humility of Christ. Honestly, I assumed this was one of those general prayers that can apply to everyone, but nothing was piercing about it that convicted me. After a while, I was still praying and meditating on this false humility concept and thought to myself, could this be me? Am I walking around with false humility? My first answer was no… and so was my second answer. The more I prayed that prayer, the more I began to feel God's presence surround me. Not in a judgmental way, but I physically

felt the fatherly presence of God just hug me. I didn't realize that I was so prideful.

As single people, we are constantly reminded of how "independent" we are or need to be. We begin to fend for ourselves because we have to do it all. We go out, kill the dinner, bring it home, cook it, eat it, and clean up all the mess! If you don't do it, it won't get done. There's no one else to depend on. Living in this cycle, especially as a woman, can have you thinking that you are the reason your life is so good. We'll stack up our bank accounts, degrees, job titles, and more and then say that we have all of this because of what we did. This is where I struggled. I had somehow gotten to a place where I said, "I don't need a man; I got this on my own."

I remember sharing with one of my brothers in Christ that Jesus was my husband. This was a moment of false humility. Not because it's wrong to say and believe things like this (even though scriptures never tell us that Jesus got married), but wrong because I was not living it with conviction. I said Jesus was my husband, but I was placing all my wealth and value and credentials in the front instead of him.

Humility is about allowing God to defend and provide for you. Being humble does not make us soft women. It makes us strong women because we know that God will fight for us and cover us. This is why the last part of the scripture in 1 Peter reminds us that God is concerned with our affairs.

When we humble ourselves with God, we don't have

to put on a front like we're better than the next single gal or better than a married gal. A woman with humility knows precisely who she is and who God called her to be. Once you've got a good understanding of this, you will be highly esteemed, and it will have very little to do with your accolades or accomplishments. You will be exalted because you know that whatever you need, for whatever position you are in, can only come from God. Abishag wasn't going around town bragging about how great of a servant she was, but greatness came to her when it was time. This is the way we should go about our days, with a spirit of humility. Humility will grace us to be more faithful in our positions and the things we do.

If we're honest with ourselves, we have very few days when we arrive at work on Monday morning thinking, "I have exactly what this company needs to thrive and go to the next level. I have, and I am the solution to the problem that exists at my job, in my community, and in my family." How different would our lives be if we took the heart of Abishag? Yes, your job, family life, and community may be passionless. It may be stuck in a routine of life-draining experiences, but you have been placed in that situation to bring forth life.

Abishag was brought in during the last days of King David's life. Most people would look right over that opportunity because we all know the inevitable is coming. He's going to die. There's no energy and excitement coming out of this guy. Sometimes, we say that about the position in which we fill. We proclaim that our jobs don't satisfy us, nor do they pay us

enough. But do we ever just thank God for the favor of the position that we're in? Do we ever stop complaining to see that we are the answer to the problems we complain about? If God placed us in these positions, we've got to trust that our being there has a purpose and will enrich the people, places, and things within our reach. When we are faithful to small things, we become targets for bigger things. It doesn't take long, but it does take the right heart.

I'm not saying be faithful to get what you want when you want it without having to work for it. I'm saying be devoted because it pleases God for you to operate and function in what you were created for. Here's what you can expect when you live a life of faithful service:

"So then, my dear friends, stand firm and steady. Keep busy always in your work for the Lord since you know that nothing you do in the Lord's service is ever useless." (1 Corinthians 15:58, GNT)

"Whatever you do, work at it with all your heart, as though you were working for the Lord and not for people. Remember that the Lord will give you as a reward what he has kept for his people. For Christ is the real Master you serve." (Colossians 3:23-24, GNT)

"So then, my friends, because of God's great mercy to us I appeal to you: Offer yourselves as a living sacrifice to God, dedicated to his service and pleasing to him. This is the true worship that you should offer." (Romans 12:1, GNT)

"I give thanks to Christ Jesus, our Lord, who has

given me strength for my work. I thank him for considering me worthy and appointing me to serve him." (1 Timothy 1:12, GNT)

"His master replied, 'Well done, good and faithful servant! You have been faithful with a few things; I will put you in charge of many things. Come and share your master's happiness!'" (Matthew 25:21, NIV)

Stop and think for a minute or two about the positions to which you are assigned. Do you realize that God ordered your steps and ways so that you could fill that position? He prompted every thought, meeting, introduction, and assignment to place you exactly where you are in life. Of all the folk in this world, that position that you're in now was created especially for you. You have the heart, kindness, joy, education, attentiveness, maturity, wisdom, grace, anointing, power, know-how, strength, audacity, tenacity, compassion, resilience, and boldness to get the job done! And let's be clear, this is the present-day YOU. Not the future you when life is seemingly more perfect or pleasant. Today's version of you, wherever you are in life, is the version of you that your community and our world need to experience.

I like that the Bible reveals to us the depth of Abishag's beauty. It seems very vain at first, but let's look at it from another perspective. Beauty has several different components. Beauty can be a combination of qualities, such as shape, color, or form, that pleases the aesthetic senses, especially the sight:

• A combination of qualities that pleases the intellect or moral sense.

- Attractiveness, prettiness, good looks, comeliness, allure.
- Denoting something intended to make a woman more attractive.
- A beautiful or pleasing thing or person, in particular.
- The pleasing or attractive features of something.
- An excellent specimen or example of something.
- The best feature or advantage of something.

Abishag's beauty had to encompass every component in the list above. The Bible refers to Abishag as very fair. With that sort of emphasis, there was no hiding of this girl's outward beauty. What is most flattering is that all these definitions speak not only to the physical beauty that one can possess but also the nonphysical qualities that are beautiful. In other words, your character as a woman can add or take away from your beauty.

We've all heard the old adage, "Beauty is in the eye of the beholder." I conclude that it was not merely Abishag's physical beauty that was upstanding, but also her character. The Bible tells us that several of David's officials (men) went out searching for the perfect woman to serve him. It's arduous to narrow down the ideal beauty, so the character of Abishag must have set her apart. That's the kind of beauty I'm describing. It's always a good feeling when your beauty is complimented. As women, a compliment from the right person can set us on cloud nine for an entire week! Likewise, a compliment of our character, our efforts, and our presence puts us on cloud 9, 10, 11, 12, and so

on! We know that our beauty will fade as time goes on, but our character will be who we are forever.

Simply put, our character has the power to place us in positions that we wouldn't usually be privy to. If we want to eventually sit in high places, we must allow the fruit of the Spirit to take root in us during challenging times. That's how character is produced.

We see that Abishag, a young, unmarried virgin, found herself to be quite powerful. Through her humility, faithfulness, maturity, and responsible ways, she served a king. She had a big assignment but a small role.

Don't take for granted the "smallness" of where you currently stand. Though your position, duties, and title may be small, your assignment is great. You are the solution to someone's problem. Accept the small roles and turn them into big opportunities to glorify God.

Reflection Questions

What positions do I hold in my life that require my time and talents?

How am I glorifying God in these positions?

Being transparent, where can I improve my faithfulness in this area?

Which of my sisters or mentors has "mastered" this area and can help me be accountable to my goals above?

Worship:
"I Won't Let Go"- *by Claudia Isaki*

Prayer:

Father in Heaven,

You are awesome! You have not only breathed life into me, but you have endowed me with talents, skills, unique giftings, anointings, and disciplines. I am grateful that you were intentional about my life here on Earth. Lord God, show me the purpose and calling you have graced me with. Let me find contentment and joy in serving God's people with my gifts and talents and not with my body or physical appearance. May I reflect the character of Christ at all times so that all may see Jesus in me.

In Jesus' Name,
Amen..

3 ORPAH
RUTH 1:1-9

Sorry ladies… no fairytale here. This chapter is going to challenge you. This will make you uncomfortable. This will involve you taking risks. Even if you consider yourself to be a risk taker, we all have a comfortable place. We all have that safety net that is always there when needed. Your safety net could be job security, educational accolades, the consistent friendships and family, your favorite vacation spot or simply your hometown. We all have one or many safety nets in our life. So did Orpah.

Our first and only introduction to Orpah, not to be confused with Oprah, the mogul, is in the book of Ruth. Just like the beginning of this chapter, the book of Ruth starts out very bitter and cheerless. At first glance it lacks any hope, faith, or ultimate blessing. We usually do a quick read through the first chapter so that we can get to the good part about Ruth and Boaz.

If you've ever been to a Christian singles'

conference, I'd bet money that Ruth had an entire session or sermon related to her story. Let's face it, the book of Ruth stars Ruth herself and her rich, soon to be beau, Boaz. It could be said that Ruth makes Orpah relevant, right? However, when I prayed to ask God which women to highlight throughout this book, Orpah's story made the cut. Why would a lady of little significance be important to consider? Let's see what we'll learn.

Orpah's current situation is jacked up. She's just lost her husband and now she's hanging out with her mother-in-law (who has just lost her husband) and her sister-in-law (who has just lost her husband.) Did you catch that? Not one, not two, but three single ladies, in mourning with nothing. No money, no inheritance, no hope, nothing! Pause for the cause: There is grave danger ahead when you hang out with those in the same struggle as you.

When you're going through, pray that God will insert the right people in your life who will bring you back to a place of encouragement, hope, faith, and trust in God's promises for your life. This does not mean that you have to cancel all your friendships. You may just need to seek new ones that can see something different than your current situation. It's no wonder that Orpah struggles with trusting God and walking by faith. Could you blame her? But life wasn't always like this for Orpah.

Orpah was a Moabite woman. She had been married for ten years to Mahlon, a businessman with joint partnership in the family business. Although successful,

Mahlon, his father, and his brother had just died. To paint a picture here, Moabite women are frequently depicted in a negative shadow. They are recorded to have been women who worshiped sex gods, had orgies, and married outside of their culture. Lot's wife and daughters were also Moabite women, which I feel is a pretty good explanation for what's going on with Orpah. We see Moabite women always losing to their past. Either nothing good comes from it or the comfortable things from their past prevent them from desiring the new things that await them in the future. Orpah was essentially stuck in the middle. Her past (comfort zone) was completely disheveled and everything that awaited her in the future was foreign, unknown, unfamiliar, and required faith.

In the book of Ruth, we see Orpah with her mother-in-law Naomi, and sister-in-law Ruth. They are journeying to Judah in hopes of starting a better life. You might think that Orpah would have been in better spirits knowing that the final destination would be a place of provision. Anything would be better than trying to survive in a famine, right? However, the Bible shows us that Orpah experienced a great deal of pressure and anxiety, which ultimately affected her choice to turn back to the familiar.

Anxiety is defined as a feeling or worry, nervousness, or unease, typically about an imminent event or something with an uncertain outcome.1 I believe that as we get older as unmarried women, the enemy will greatly attack us with this pressure, worry, anxiety, unease, and nervousness about our future. This pressure usually lies within getting married and having kids at a

"healthy" age. You know… the clock is ticking.

This same type of anxiety attacked Orpah when she was faced with a decision to move forward in faith or fall back into fear. I hate the demon of anxiety because it forces one to pause their life. It makes you feel stuck. Reliving the worst parts of your past and questioning if you'll ever see the promise of your future. What is interesting in Orpah's story is that she did not start in this place. Initially, she agreed to accompany Ruth & Naomi in their journey to a new land. However, when a greater commitment was required, she was shrouded in obscurity. At one point, Orpah made the choice to step out of her pagan past to marry into the Jewish family. Since she never converted, we can see that Orpah lived one foot in her comfortable, pagan world and one foot in the new promise "Orpah would love to be the heroine of the book of Orpah but she simply cannot muster the courage to sacrifice her ease and her everyday comforts on the altar of the Big Idea. Her sin is a sin of omission, of cowardice, of lack of vision. She is a good person who means to do well but just isn't cut out for self-sacrifice and mighty deeds."[1]

There have been plenty of times in my singleness when I wanted to be courageous and "proud" to be single, but I didn't have the courage to be that woman. I would idolize successfully single Christian women from afar. They were doing this "single life" so well. Serving the Lord, conquering their fears, and making life look so beautiful. Meanwhile in Lonelyville, I was holding on to my past, waiting on a pseudo fairytale/redemption story of past relationships and hoping to have a life as complete as some of the women I secretly idolized.

One day, by the grace of God, the Holy Spirit showed me how I had allowed my past to cripple me and keep me from enjoying not only the present moment, but waiting with an expectant hope for the future; a life lived without fear, anxiety, and societal pressures. I wonder how much "life" we've missed out on because of these attacks of fear, anxiety, and pressure performance for the world.

Our enemy, Satan, wants to dismantle our hope, faith, trust, and future with God. This is exactly what happened to Orpah. What if Orpah was meant to end up like Ruth? What if she moved forward? What if she faced her fears and courageously walked into the unknown?

I won't lie, the future of the unknown can be a scary thought. But because Jesus lives and because our Daddy is God and because the Holy Spirit is a teacher, comforter and guide, the future is ALWAYS greater than our past. There's no benefit in crying over failed relationships and dreams deferred.

Sometimes our past grips us because it's comfortable and familiar. I've learned that those excuses only perpetuate an independent and wavering spirit within oneself. This means that you'll only go into territories and spaces that you can control. But here's the issue:

[8]For My thoughts are not your thoughts, Nor are your ways My ways," declares the LORD. [9]For as the heavens are higher than the earth, So are My ways higher than your ways And My thoughts than your

thoughts…. (Isaiah 55:8, BSB)

You see, if you only feel safe and comfortable in places that YOU control, then you'll never experience the FULL life God has promised and destined for you! What happens when you reach your capacity? What happens when your skill and intellect tap out? Will that be the end of your journey? Sis, you're missing out! Let me say it again: if you're doing life by your own understanding and comfortability, YOU ARE MISSING OUT! We must learn to trust wherever God is leading us! The fact of the matter is that God has already been in that place and He has already ordained that place to bless us. Yes, the blessing may come in ways that challenge us or develop us or cause us to give up control, but at least we know who we are giving control to.

I wished that Naomi and/or Ruth would've just smacked some sense into Orpah! I'm not advocating abuse by any means. I just wish Naomi would've shared her wisdom and faith with Orpah to let her know that every storm has an expiration date. I'm sure this wasn't the first time Naomi had been faced with hardship. I wish she would've been a bit more persuasive instead of giving Orpah a choice to stay or leave. I wish Ruth would've declared #NotMySister. I wish she would've said something like, "Orpah…girl, c'mon. Stop wallowing. This is the chance for a new beginning. This is a chance to live again!"

Maybe things would have been different if Naomi would've been in a better place to encourage Orpah to stay. Surely if anything could come out of this

unwelcomed adversity, it would be the silent lesson of an enduring mother. Let's pause for the cause right there.

Beloved, one of the most beneficial and fruit producing relationships we can have in the body of Christ, is that of a spiritual mother or a mentor. I pray that God sends you a mature and seasoned woman in the faith that will show you how to persevere during hard times. The purpose of spiritual mothers is not to abuse or control you. They are there to teach us, love us, guide us, and show us a healthy example of a believer. The right spiritual mother or mentor will give you for free, what they had to pay for in tears and lessons learned. Just like our natural mothers, we don't always get the opportunity to choose this woman on our own terms. But, if she is a woman of God, consider yourself blessed and favored that the Lord is sending you someone to help you along this journey. Glean all that you can from her and honor her voice in your life, both audible and silent. She's a Godsend.

We don't know if either of these conversations happened with Orpah. Perhaps they did. What we do know is that she had a choice to make. And yes, it sucks that she had to make this choice after one of life's greatest blows. It sucks that she was still in a period of grief, mourning and famine. But she had to make a choice.

In our life we will be faced with these moments on many occasions. Maybe not as severe, but hardship is inevitable. Here's the lesson learned: every single moment to go back is also a potential moment to go

forward! It's called choice or free will.

Webster's Dictionary defines choice as: *an act of selecting or making a decision when faced with two or more possibilities.* Take a look at some of the synonyms for choice:

- Option, alternative, possible course of action
- Range, variety selection, assortment (when more than one choice is presented)
- Preference, selection, pick, favorite

I have learned that in order to have true peace in God, we have to thank Him for His system and His plans. This means, regardless of my choice, error, or mistake, He has a plan to bring me out of it, if that's what I desire. This is not a free ticket to live life recklessly and without concern for your future. This is simply a reminder that God is rooting for you and only wants to give you His best!

This is your season to be resolved in choosing God's ways for your life. Once we embrace the fact that God has an answer and even better, the solution to everything in our lives, we will triumph. There's grace for mistakes, sins, wrong decisions, ignorant decisions, arrogant decisions and more. The Lord recognizes the courage it takes to make a choice. Orpah has been getting a bad rap because we liken her to Lot's wife. When she made the choice to forsake both Ruth and Naomi, she lost all street cred with us.

However, I gotta give Orpah her props because she made her choice. We really don't even know if it was in

fact a bad choice, simply because we don't hear from her again. Truth be told, Orpah could be hanging out in Heaven with Ruth right now, unbothered by what we think about her (you can laugh here).

The point is, we have the power to choose. Doing nothing and expecting something to happen just doesn't work. Wallowing in pity, doubt and fear won't get you to the place you want to be.

What can you choose today, in this moment, that will get you one step closer to where you need to be? Do you need to exercise, plan a trip, call your family, make an appointment with a therapist, drink more water, read a book, hang with friends, get some rest, or even just take a step back and reevaluate how you got here in the first place? Well, guess what? You can do that and more with Christ! (Philippians 4:13) Remember, He has already set up a system that is mistake proof. You can't go wrong when you make the choice to choose God.

Sometimes the first step you should take is to declare something different. Our words have power and we've given too much volume to our fears, discontentment, and struggles. Instead of amplifying those things, make a choice to give a voice to your promise according to God's word! From this point forward, our choice is to choose God's way...even if we can't see what that is.

The Bible commands us to be living sacrifices in Romans 12:1-2. In the New International Version, it reads:

¹Therefore, I urge you, brothers and sisters, in view of God's mercy, to offer your bodies as a living sacrifice, holy and pleasing to God—this is your true and proper worship. ²Do not conform to the pattern of this world, but be transformed by the renewing of your mind. Then you will be able to test and approve what God's will is—his good, pleasing and perfect will.

Even though this is a command, many Christians treat it as an option. When we pray this prayer and receive help from Holy Spirit, we reject the timelines, fears, anxieties, and pressures of this world! Our thinking changes, which then changes our perspective and the way we react to whatever the enemy could throw at us. Whether it's rejection, fear of the unknown, hurt, loss, loneliness and even anxiety, we can see it through the lens of Christ. Doing this work daily in our Christian walk, empowers us to choose the good, pleasing, and perfect will of God. Doing this work keeps our attention on the things that matter most and less on the things that don't.

Orpah's story could have been epic. She and Ruth could have been the poster girls of hope and restoration! But we will never know what could've been simply because she did not choose to move forward. But she did make a choice, nonetheless.

My prayer for you is that God will send you an accountability partner that will push you to choose God's path for your life. I pray that when you want to go back to the former life of comfortability, that you are reminded and recharged by the promises of God that will come to pass. I pray that you will perceive the new

thing God is calling you to.

Orpah had to decide between courage and comfort, a choice between fear and faith. Know that when you make up your mind to follow Christ, you will most surely be tempted by the enemy to resort back to what was easy and comfortable. Believe that when you finally find your peace and trust God, your emotions, society, doubts, fears and even those closest to you may try to rain on your parade. That's okay. Just keep moving onward and upward. Make the choice to keep going no matter what! There's a promise from God on the other side but you must keep moving forward to see it.

1:
https://torah.org/learning/ruth-class10/?print-posts=print

<u>Reflection Questions</u>

What experiences from your past does Satan use to introduce fear, anxiety, and distrust?

What scriptures can you find in the bible to consciously declare over your life to combat these feelings?

Worship
"My Everything"- *by Brianna Babineaux*

Prayer

Father,

Thank you for the new life you have given me. Lord God I praise you because even through the rough moments of my past, you were there. Not only were you there, but You had already provided the solutions and strategies to bring me out of that place and into a new place of hope, joy, peace, and love. I pray that from this day forward to choose you and your ways every single time. May I know that any option in Christ is so much greater than returning or staying in the places you have brought me out of. Though, the future is uncertain, I choose to trust the one that is already there. Lead me and guide me, all the days of my life.

In Jesus Name,
Amen

4 THE DAUGHTERS OF ZELOPHEHAD
Num. 27:1-7; 36:1-12; Josh. 17:1-6

The Daughters of Zelophehad are unlikely candidates for this type of book. Though the "absent" man in their life is a father, not a husband, there is still a victorious lesson of boldness to learn from their story. After initially reading their story in the book of Numbers, I instantly thought to myself, "These five women are the Biblical Charlie's Angels."

The Daughters of Zelophehad, Mahlah, Noah, Hoglah, Milcah, and Tirzah were all Hebrew sisters. They were a part of God's original plan. They experienced the wilderness with Moses and the rest of God's chosen people. Towards the end of this 40-year journey, they were met with an issue that could either bless or curse the future they were searching for. The land that was promised to their father was being divided and rationed to Israel's men.

Since their father had died in the 40-year journey to the promised land and there were no male heirs, the Hebrew law stated that none of the five daughters could claim their father's land in Canaan. Can you imagine? No father, no brothers, and no husband once we finally get to the place where we've been journeying the last 40 years. The disappointment and fear of the future are enough to steal anyone's joy. Do you see yourself in this band of sisters? I do.

Have you ever reached that point in your Christian walk when you square your shoulders, position your faith, and put on your victory outfit, only to find yourself journeying for a promise of what seems like 40 years?

Here's a real moment for you: Have you ever trusted God in a wilderness moment because you knew what He promised was at the end of the journey then out of nowhere, you are met with massive opposition and roadblocks to YOUR promise?

Dare I go deeper? Have you ever waited patiently, worked on yourself, and stayed faithful to God's word about a mate? Just when you think he's the one God has sent, all the warning signs and red flags come out of the woodworks.

Well, that's our dear sisters. They were exactly where you are in those moments. What God does to show He cares for them is nothing short of amazing.

The boldness of these sisters is also quite admirable. You could say that they were the biblical

version of Rosie O'Grady! In all seriousness, it's no joke when you go after something that society says you can't have. We're told that women can't have certain jobs, particular powers, individual freedoms, certain salaries, certain levels of happiness in singleness, and even certain positions in God's Kingdom. Unfortunately, our Western culture promotes the dreams of men way more than the dreams of women. Women are constantly overlooked for such things that they rightfully deserve. Yes, I know what you're thinking… Feminism Movement soapbox rant! Only part of that is accurate! The truth is this: God supports women's rights! He's our biggest supporter, advocate, cheerleader, and coach!

God never intended for women to shy away from the big things. He never intended for us to "play dumb" in the boardroom and miss out on experiences that are dominated by men. In your personal study time, look through the infinite number of promises God makes to His people. Out of all of them (that we can know on this side of Heaven), how many are gender based? How many of God's promises are locked up in the back room with a sign that reads: For Men Only? As a matter of fact, tell me which of God's promises have any limitations such as weight, height, skin color, ability, socioeconomic status, or education level? Not even one. The only requirement to inherit what God has for you is to receive it by faith.

The Daughters of Zelophehad were just that bold. In essence, they were breaking all sorts of rules. The Law of their day did not favor women, especially when it came down to money, power, and respect. But they knew who they were and who their Daddy was! So, let's

look at three critical components of their bold request.

- They knew their father.
- They knew what their father possessed.
- They desired more out of life.

It is clear that these girls had a relationship with their biological father. They knew him, and they knew him well. Simply put, they were Daddy's girls. They knew his family, the life he led, and what he left for them. When we get to know our Heavenly Father, all these things are revealed to us as well. Getting to know God is not difficult, but it does require commitment. Just like any healthy relationship, getting to know our Heavenly Father needs time, communication, honesty, and trust. While we are growing in Christ, God begins to reveal all the beautiful things He has planned for us. And oh boy... He wants to give us everything that our heart desires (Matthew 6:33, Psalm 84:11). I believe this is especially true when we are still in a season of singleness.

Perhaps this is why we shouldn't wallow in our singleness but chase after Christ so He can reveal His fantastic plan for our lives. Self-pity and the spirit of rejection only pull us farther and farther away from the life God wants us to have. I mean, let's be honest...God is always and forever going to give us exponentially more than any man, boyfriend, or husband could. That's just the facts. What do you think would have happened if the D.O.Z. would have gotten depressed about their marital status in that moment? What if they would have put all their time and efforts into finding a husband only to leech off his inheritance?

Because they fought for what was fair and due them, God literally changed His rules for them!

The enemy will try to make us feel like we're insignificant because we are unmarried. He'll make us feel like we have nothing to offer and are of little to no value without a man in our lives. That is a lie! The D.O.Z. show us that we are called to change the rules of society by taking a stand. One of the most useful gifts we get from our Father is His power. All the authority that Christ has is ours to possess (Luke 10:19). You can only get that type of fearless courage by spending time with your Father.

In all this greatness, what I love most about these dear daughters is their sisterhood. They each fought for each other by fighting together, which gave each of them a unique portion of strength. After they had suffered the loss (through their father's death), they grew stronger than ever before. Take note, changing the rules of society will never be an easy job. There will be disappointment, rejection, loss, fear, and many other emotions to overcome. The key to overcoming is by sharing in the fight with someone. Don't go at this thing alone… it's too big for you to handle by yourself! Link up with some sisters, natural and spiritual, and fight together. You must surround yourself with an army of women who are praying, encouraging, pushing, and walking with you through life. This applies to LIFE, not just a season of singleness or marriage.

These sisters could have potentially been shunned from the community by speaking up the way they did. They really were pushing the envelope here, but it

needed to be pushed, especially if God pushed you to say or do something about it.

Believe me, I know what it feels like to be silenced by stifling all you are and hope to be in life. It's a weighty task. I know that you see things that are not yet conceived or existing in this world. It's scary when there are no words to describe the dreams, plans, and ideas that God has given to you. Sometimes that fear makes us want to turn and run… but deep down on the inside, we know that we're called to greater. We are called to this thing - a position, a ministry, an invention, a community - whatever God says it is, that's what we are to do. If you find yourself agreeing with this statement, then God wants you to hear this:

"¹Bezalel and Oholiab and every craftsman in whom the Lord has put skill and intelligence to know how to do any work in the construction of the sanctuary shall work in accordance with all that the Lord has commanded. ²And Moses called Bezalel and Oholiab and every craftsman in whose mind the Lord had put skill, every one whose heart stirred him up to come to do the work. ³And they received from Moses all the contribution that the people of Israel had brought for doing the work on the sanctuary. They still kept bringing him freewill offerings every morning, ⁴so that all the craftsmen who were doing every sort of task on the sanctuary came, each from the task that he was doing, ⁵and said to Moses, "The people bring much more than enough for doing the work that the Lord has commanded us to do." ⁶So Moses gave command, and word was proclaimed throughout the camp, "Let no man or woman do anything more for the

contribution for the sanctuary." So the people were restrained from bringing, ⁷for the material they had was sufficient to do all the work, and more." (Exodus 36:1-7, ESV)

In a nutshell, God's grace is sufficient. He'll send all the resources, all the supporters, all the workers, and all the materials you need to accomplish His will. Consider this: If you are unmarried now, it only means that you don't need a husband to complete the tasks He's assigned to you right now. It doesn't necessarily mean never, but just not now. Our Father has given us everything we need to be successful in this season of our lives.

Notice that there are five sisters/daughters. These daughters are also mentioned five times in God's word. God's grace was with them from the beginning. He thought so highly of their boldness, obedience, and destinies that he gave them a place in the precious Word of God. God challenges us to provide us with purpose and significance in his Kingdom. We could all just sit back and go with the flow…do things the ways in which they've always been done…but that's not going to get his attention. Be bold! Be brave! Be the change! To prove this point, let's look a little deeper at this ultimate dream team of sisterhood. It's important to note that all but one of the five times the D.O.Z. are mentioned in Scripture, their names are recorded for all to see, hear, and study. Now, most read past the names in the Bible because 1.) There are so many and 2.) because we butcher about 95% of those names! However, the D.O.Z. girls are worth the effort. Take a look at the Hebrew meaning of these girls' names:

Mahlah - sick, diseased, weak, wounded, rust, or filth. Mahlah is pronounced mah-law.

Noah - to shake, stagger, tremble, lips that stammer, quiver - just like Hannah's lips when she was praying to conceive her son Samuel.

Hoglah - Partridge, like the bird… not the family :). This is a bird that is always being chased and falls because of obstructions in their paths. The Partridge prefers running over flying unless it has someone to push it. They don't dwell in plains, grasslands, and fields but in rocky hillsides. They avoid high places.

Milcah - to be or become king, Queen royalty, power, associated with foreign monarchy, but without formal authority.

Tirzah - to be pleased with, favorable to, or accept delight, pleasantness, pleasure, beauty favorably.

Together they make up the largest cluster of female names in the Bible! Initially, I was confused. Truthfully, as I typed this information into my manuscript, I had to fight the urge to hit delete more than once. I didn't understand why the daughter's names were significant if they were sick, staggering, some cowardly bird, and so on. Then God showed me two powerful concepts that must be understood: The power of the process and the power of unity.

I believe one of the most chain-breaking truths for any Christian to receive is to know that God has a goal for every person's life AND that no one has ever or will ever be put on the same plan. Why? God is original and sovereign. He loves you too much to make your life boring, thoughtless, unoriginal, and a copycat

of what's already been done. So, stop comparing your plan with everyone else's. I know … another hard pill to swallow in this dry world of reality and practicality. As we seek God and grow closer to Him, our levels of desire change. We can find contentment and wholeness in Him. This will look different for everyone, but as long as we stay close to Him, we'll be filled. (John 4:14)

When we look at the D.O.Z., we see women who are abused, hurt, confused, nervous, scared, petrified, ashamed, and timid. Somewhere in the middle, things shift. Note that the woman is still fearful and unwilling to go any higher than her comfort zone unless someone pushes her. Ironically so, this woman always finds herself in rocky places where things may be challenging and uncomfortable.

Almost at the end of this process, we see that this woman finally recognizes her position and assignment. By the end of the process, this woman can fully claim her inheritance because her Lord has received her service and approved it. In fact, He takes so much pleasure in it that it is called beautiful, and rest, just as it is granted on the Sabbath.

When we divide the sisters and focus on them individually, it seems unfair. Some have extraordinary lives, and others not so much. But thank God for the power of unity.

Together, these women do something big. Something epic. Something worthy to be recorded in the Holy Bible. Together they are recognized as fearless leaders and an army of game-changers. There is a part

of us represented in each of these daughters. As we go through the process that God has prepared for us, we too, will be able to change the rules not only for our families but for our world.

*The D.O.Z. eventually married. They were able to keep the inheritance their father had prepared for them. Their entire lineage, at least four generations, receives a double portion in the long run, all because they linked up and went after what was rightfully theirs.

<u>Reflection Questions</u>

Evaluate your relationship with God. Is your relationship healthy or unhealthy? How do you know?

What has God asked you to do that goes against societal norms?

Who are the women in your life who incite deliverance and encourage destiny?

Worship

"Built for This"- *by Chandler Moore*

Prayer

Lord God,

Today, I thank you for the Spirit of Adoption. You are the best Father a girl could ask for. You give me purpose, a strong identity, and a great inheritance within my destiny. Allow me to walk that purpose and be 100% uncompromising in my true identity, for I know my identity is found in you. I cancel any thoughts of rejection and abandonment because you wanted me, and you continue to choose me. Thank you for the diverse array of sisters you have blessed me with. In their own way, they elevate, empower, and enrich my destiny in so many ways. The plan for my life cannot be accomplished without the right people in my life. Thank you for discernment that I may see clear motives and intents and purposes for which individuals have come into my life. I believe with your plans and the support of my sisters, that I can do all things through Christ which strengthens me (Philippians 4:13).

In Jesus Name,

Your Wonderfully Blessed and Destined Daughter...

5 HADASSAH/ESTHER
Esther 2

I love Hadassah (Esther) as a Biblical figure. She does things big. Mother Theresa said, "If you're scared, do it anyway as scared as you may be." This is how I think of Esther. She keeps going until she reaches her final destination. It may seem like an easy thing to do, but it's not always like that. Considering that Esther came from an orphaned status, her obedience brought her to the place where not even a king could deny her.

If you know the story of Esther, you're probably questioning how she got a cameo in this book. If we're honest, between Esther and Ruth, us single ladies know their stories left to right, front to back. We celebrate that these women are not only our examples of what a single woman "wait" should look like, but they actually get it all. Not just any man, but Kings and Kinsman Redeemers. Oh no, what we love about their stories is that they actually come out on the winning side. Let's just be real, the stories of Queen Esther and Ruth are a Christian girl's fantasy. Or at least that's what they want

us to believe.

Nearly all Christian women's books include Esther in some kind of way... I couldn't escape it. There's so much to take away from her story. Yes, Esther was indeed chosen by the King, but she spent time as a single woman with a genuine ministry and essential calling. Esther's people needed her to remain single until her appointed time. Excuse moi`?

Yes, it's true. Esther's people needed her to remain single until an appointed time. Now, don't roll your eyes at these clean white pages and toss this book into your wastebasket. Let's see what we can learn from her sacrifice. I mean, she did do something right! Most single women just want a Man, but God rewarded Esther with a King. Touché. So, I invite you now to pray to God for an open heart to hear a simple word about two principles that never get easy, whether married or not: Sacrifice and Obedience.

Before we get to the good stuff, let's start with obedience. Obedience is defined as compliance with an order, request, or law or submission to another's authority. By definition, obedience seems to be of no harm and loaded with a possibility of remarkable outcomes. Obedience is considered to be upstanding, responsible, thoughtful, and wise in most cases. I've never heard of an obedient person being scolded, reprimanded, or shamed for complying. Romans 5:19 puts it this way:

"For as by one man's disobedience, many were made sinners, so by the obedience of one shall many be

made righteous." (KJB)

If this is true, why then is obedience so difficult to act out?

Many times, in living as a single person, it is easy to act out of selfishness rather than selflessness. When you're able to come, go, spend, save, eat, and sleep as you want, it is the flesh's natural response to continue to do for you. It's one thing when you're in your Mother Theresa super saint mode, and you just want to be everyone's guardian angel, but let's be honest… how often is that the case? Typically, it's not the case. This doesn't mean you're a terrible person; it just means you've got things that you want and need to take care of for yourself.

Not having a husband or kids tends to make this notion a reality 24/7/365. In fact, that's one of the perks of being unmarried. The fact that you can be concerned with just you. In moments where you may have to worry yourself about others' affairs, it is merely an inconvenience. Often obedience is a great inconvenience, even as a single person.

However, this "perk" can also be manipulated and abused by the enemy. Yes, there's a time in our singleness where alone time and solitude is refreshing. This time in our lives does not and should not blind us to the selfless life that God wants us to live before adding the company of a husband and/or children.

Hadassah had been inconvenienced, as a single woman. Now, she would be concerned with the affairs

of many, like a whole nation! In her Bible story, Hadassah beautifully models a life of obedience, humility, benevolence, and altruism.

I believe we learn this from Hadassah how she accepted her position and timing in Almighty God's plan. As unmarried women, this is something we must learn to welcome and agree to. Selfishness is a deceptive killer of this because it will always be about you and your timing. Agreeing to God's timing means that you will be available to Him even when you have another agenda in place.

Have you ever asked yourself what would have happened if Hadassah had dismissed the wisdom and requests of Mordecai? What would be her story had she not willingly obeyed or heeded Mordecai's instructions? Would she have even been noticed by the eunuchs? Would we give her as much airtime if she just kept living life for herself?

One trait that I can genuinely appreciate about Hadassah is her humility and meekness. These two essential qualities certainly made her stand out amongst thousands of other women. How crazy is that? The world will teach us to live large and in charge, command the room, make our presence known, and our absence even greater. But not Hadassah. No, she recognized how to make big moves in silence.

Oftentimes as single women, we can amplify the things that lend for a positive reaction or response from the crowd, especially on social media. We feel the need to celebrate publicly, even when our private spaces are

filled with chaos, clutter, and despair. Now note what I'm saying here. This is not a chastisement of celebrations and honoring your journey. No beloved, this is about the need some of us have to go public with it. Social media pressure has taught us that our best moments are worth more than the not-so-great ones. If Hadassah had a Twitter account, I imagine much of it would be retweeted from her mentor, Uncle Mordecai.

I would argue that one of the most significant relationships a single woman can have, other than her relationship with Jesus, is that of someone who carries the spirit of Mordecai. Make no mistake about it. Just because Mordecai is a man in the text doesn't mean that's what we have to go and find. In your life, the modern-day Mordecai are the individuals in communion with the Holy Spirit who operate in wisdom, discernment, and give prophetic instructions. Somewhat similar to Naomi in Orpah's story, Mordecais don't necessarily come to make you feel good. They will make you uncomfortable because they recognize God's call on your life, sometimes even before you do. Mordecais are the gatekeepers and will cover you like they protect their own.

Hadassah had no clue that her status was soon going to change. I think many of us, whether you believe it or not are in that very moment right now. Some of us think where we are is what it will be like for the rest of our lives. Re-reading Hadassah/Esther's story helped change my mentality on this type of unhealthy thinking.

I honestly struggled to hear from God concerning what to write about Esther. Although notable, her story

has become somewhat of the single lady anthem related to unmarried women in the church. Nothing about her story has changed, and no new revelation has come from it. It is somewhat discouraging because how many of us really are going to get to marry a King? Yes, it'd be nice, but then when you really think about it, how many of us really want the position of being a queen? Remember when Megan Markle, the American movie actress, wed Prince Harry? What a dream! Or so we thought. I remember reading an article on all the details and preparation for the wedding day, let alone Megan's new responsibility and all she had to submit to just to become a princess y'all. It included things like what nail colors she could wear, how to sit and cross her legs, and all the functions she would attend. The list was painstakingly long, and just when I thought I wanted to be married to a prince, it all went down the drain after reading this. Since the wedding, Princess Megan and Prince Harry have made headlines because they are making their own rules and doing things the way they want to do them.

I thought about this concerning Esther and then even more about us as single women. One underappreciated quality I admire about Hadassah/Ether was her ability to be authentically herself. All the way down to sacrificing her life so that her people could be saved. She was authentic to her passion and her purpose. Her assignment was not like anyone else's. Let's talk about comparison...

Yeah, I know, but we've got to deal with it if we are going to commit to God's calling on our lives during singleness as well as in marriage. There's a famous

phrase, I believe it was coined by gospel recording artist Jonathan McReynolds, that simply says, "Comparison kills." Ouch! Can I tell you that those two words sting me every time I find myself in a state of low self-esteem or self-worth because of my fixation and infatuation with the life of another? This one is tricky because comparison in its purest form can really begin at the seat of admiration, which is not necessarily bad. Admiration can be innocent, but it can also be dangerous.

The Bible says that we are to admire God's handiwork. Admire the way He shaped the world and the way He formed and created us in His image. Yet when distorted or exercised in the wrong way, admiration can be fatal. This is where learning, becoming, and knowing your true authentic self is so important. When we stay true to our authentic selves, we can have a healthy admiration and still remain focused on who God has called us to be.

Too often, we desire the looks, possessions, and spiritual gifts (and sometimes husbands) of those we admire and then begin to idolize them above God. It sounds something like, "Wow, she can really pray with fervency and power; I wish I could pray like that." Or "I bet if I looked more like her, then I would have no issue getting a date." When we walk into the enemy's trap of comparison, we diminish the rare beauty that God created us with. I often feel the need to remind myself that God did not make a mistake on me. This applies to everything from my outward appearance to my natural gifts and talents all the way down to the purpose and assignment He has put inside of me to complete.

There's a unique purpose in your life, and it can only be achieved by walking in authenticity.

"Well, what if I genuinely don't like who I am, Krystle. Then what?"

Well, sis, first, I've been there. I've been that girl who was displeased with 99% of her life, body, and everything else. And I've also been the girl who cried out to God to show me what it was in me that made me so special. It hit me like a ton of bricks—a relatively simple concept: God made me. That's it. Let that settle.

Think about the intentionality of our God. Think about everything that we know of (to this date) that was made and created by God. Let's start with time. God created that. Then consider the intricacies of the universe. God created that. Then add the wonders of the Earth. Now consider the water, the air, the grass, and the animals. Okay, now rest on this... the complexities of human life... throughout time, mind you. And then, finally, little ole you. After you, there was nothing left to create. Go ahead and check the facts. Genesis... we were the last thing God created and the only thing He formed. What does that tell you? Take a moment and capture what Holy Spirit is saying to you about this.

God speaks audibly, and He also speaks with His actions. And the fact that He stopped creating, sat back and marveled and proclaimed, "It is good!" says a lot. To me, this is an indicator that God is pleased with who He made you to be.

Yes, He could have made you like this person or given you these specific qualities, but He sat back and marveled, dusted off His hands, and said, "It is good." You can insert your name in the placeholder of "it." For example, Krystle is good. Tasha is good. Brandy is good. Cindy is good. Mackenzie is good. Danielle is good. Paige is good. Lauren is good. Ashleigh is good. Mary is good. Lydia is good. Laurel is good. Elon is good. Kacey is good. Melissa is good. Joanna is good. Andrea is good. Amber is good. Ari is good. Taylor is good. Kimmy is good. LaShauna is good. Valerie is good. Paige is good. And You...you sis, you are good. Notice God didn't say you were good enough. Oh no! You are good, period. With an emphatic finality, meaning there's nothing more to say about it. I like it-- no, I love it, just the way it is.

Hadassah shows us this in many ways. The setting of her story could be a breeding ground for competition. Instead, Esther (Haddasah) fixes her gaze on her uniquely divine purpose and finds her authentic self along the way. We could imagine what her life would have succumbed to had she allowed her insecurities, envy, and self-doubts to take over. Her story probably wouldn't be all that unique and powerful to those of us reading it today. When others sought the king's attention by peacocking, Esther chose authenticity. Even at the thought of replacing the beautiful and highly regarded Queen Vashti, Esther still stays true to who God called her to be.

Knowing your worth and God-given value can save you a lot of mental energy, especially when it comes up against your identity and purpose. As a matter of fact,

when you walk daily or show up as your most authentic self, people come looking for you. You won't have to insert yourself into any conversations. You won't have to keep up with the Joneses. You won't even have to introduce yourself by your title or accolades. All you have to do is be. Just be. Esther was just "being" when Hegai took a particular liking to her.

Imagine all the beautiful and most desirable women in the country in the same room together, and she's the one? She's the one picked out of them all. Her past and where she came from didn't even matter. Wouldn't it be a shame to walk around pretending to be someone/something else only to learn that what you wanted, wanted YOU too? And they kept overlooking you because you were fixated with looking like someone else? Devastating.

I don't know about you, but I want to know how Esther did it. How did she walk around in the harem with all the other beautiful virgin women and keep her heart and mind free from the volatile death of comparison? And maybe she didn't. She was only a young teenage girl when all of this was happening in her life. Sometimes, we feel like life is happening to us against our own will and desire. Despite our efforts to improve or fix things, sometimes life happens beyond what we can control.

We will always fare better when we take ownership of and control what we can. The spirit of comparison is one of these things. You know that we can conquer this because the Bible gives us guidance on how to do so.

"Not that we dare to classify or compare ourselves with some of those who are commending themselves. But when they measure themselves by one another and compare themselves with one another, they are without understanding." (2 Corinthians 10:12, ESV)

"Make a careful exploration of who you are and the work you have been given, and then sink yourself into that. Don't be impressed with yourself. Don't compare yourself with others. Each of you must take responsibility for doing the creative best you can with your own life." (Galatians 6:4-5, MSG)

"A tranquil heart gives life to the flesh, but envy makes the bones rot." (Proverbs 14:30, ESV)

"For am I now seeking the approval of man, or of God? Or am I trying to please man? If I were still trying to please man, I would not be a servant of Christ." (Galatians 1:10, ESV)

After all is said and done, you've got to know that you have a superpower in simply being you. Celebrate you. Honor your story. Focus on your purpose. Go through your process. And ultimately obey God's calling on your life. There's always going to be someone better, faster, stronger, prettier, and wiser than you, but there's only going to be one you on the Earth for all time. Do you see how powerful that is? Even somewhat scary. Don't let it scare you, but let it motivate you. There really aren't words adequate enough to describe how special you really are to God our Father. If He wanted clones of the women you admire, He certainly

could have created more of them. But He didn't. He created you.

If you find that you continue to fight with this area in your life, I want you to know that you're not alone. More importantly, I want you to know that I am praying for you. This is no easy feat, but practically there are some things that you can do to grow in this area:

1. Spend time daily with God, our Father, the Creator. Planned and unplanned.
2. Read and study the Word of God to discover your identity. Cosmo, Ebony, and Marie Claire can't help you with this one.
3. Pray to know your purpose and the confidence to walk in it.
4. Obey God radically.

I'm not sure if Hadassah, at her young age, even realized this. Nonetheless, this is the encouragement that her story brings time and time again. Whether you're learning of her story for the first time or you've got it memorized, there's no question that her obedience and sacrifices made way for a favor and an open door that only God could have provided.

Reflection Questions

What area of your life do you often compare to everyone else's?

What has God revealed to you about your uniqueness in the Earth?

What are 1 -2 ways you can practice being more selfless this week? Write them down here:

Worship
"More Than Gold"- *by Judikay*

Prayer:

Dear Lord,

Thank you for who you have made me to be. Your word says that I am fearfully and wonderfully made by you. I ask that you would show me what you see when you look at me. Heal me from any residue of rejection, abandonment, and an orphan spirit. Teach me how to live boldly in my most authentic self and remind me of this uniqueness when I need it the most. Make me aware of my superpower and my covenant promise with you so that I won't covet or envy the lives of others. Lord cultivate within me a heart to radically obey your instructions so that I may know you and obtain your promises for my life. Thank you for crowning me with your glory.

In Jesus' name,
Amen

6 PHARAOH'S DAUGHTER
EXODUS 2:5-10

**This chapter will explore themes of motherhood. Some single ladies are already mothers. If that's you, I still encourage you to read this chapter. You may gain new insight, or you may gain an understanding and compassion for your sister without children. Either way, I pray it motivates you to appreciate motherhood and know that God can still have a great purpose for you as a single mother.*

One aspect that can be most challenging for a single woman is the hope of motherhood. Some women have an earnest desire to conceive, birth, and nurture a child. While I recognize that this desire may be more robust in some than others, there's no denying that God put a special anointing within the woman to bring forth life. He gifted us with the responsibility of nurturing. For an unmarried woman, this desire can be so strong and, at times, overwhelming. Science, society, and even family members have become the most prominent antagonists in this fight. My job is to tell you this: Don't be

discouraged if you've not yet become a mother. There is still time, and God knows that perfect time for you. The truth is this: True mothers, mother.

In the hustle and bustle of this world, it's easy to only view mothers as a simple noun. We are taught that being a mother is something that one is. However, being a mother is also a verb. If you are called to be a mother, chances are that you have already mothered. A mother's definition is to bring up a child with care and affection, look after kindly and protectively, and give birth to. So, think about that younger sibling, next-door neighbor, and the little girls or boys you unknowingly mentor - or mother. God has already acknowledged you as a mother. He knows the time when you'll be most prepared and most available to mother. Not to mention that He gave Sarah a child in her old age.

Like Sarah, sometimes we laugh at her story, but remember nothing is too hard for God! Wait and trust and believe God will grant you the desires of your heart, and in the meantime, keep reading!

So, I didn't know what lesson Pharaoh's daughter would teach us, but I'm glad the Lord prompted me to share her story with you.

Pharaoh's daughter-- his only daughter, was one of a kind and a bit of a rebel with a cause. Though born into wealth, power, and notoriety, her sincere heart captured the hand of God. She is first mentioned in the book of Exodus. To really get the full scope of her significance, we need to get some back story.

The Egyptian King, Pharaoh, had issued an

order for all Hebrew male children to be killed. Welllllll, Pharaoh had a bit of a problem on his hands. The midwives he ordered to kill the infant boys feared God more than they feared him (You go, girls!). Thus, they did not obey the Kings' order, and every male infant that was birthed through the midwives lived! It was then that Pharaoh charged all his people to cast the male infants into the Nile river. Before we get angry with Pharaoh, check out how his evil plan of fear and hatred allowed his daughter to be used by God.

When I think of this story, the scripture that comes to mind is Romans 8:28, which reads:

"And we know that all things work together for good to them that love God, to them who are the called according to his purpose." (KJB)

Another scripture, Psalm 138:8, says:

"The Lord will perfect that which concerneth me: thy mercy, O Lord, endureth for ever: forsake not the works of thine own hands." (KJB)

Pharaoh's daughter was unexpectedly hit with the "compassion" arrow. This did not come from cupid, but it came from God our Father. She took one look at Moses, and her heart was filled with compassion.

Some unmarried women struggle with their singleness because of the desire to birth children. In contrast, Pharaoh's daughter was not in this place. She was enjoying her life…free to come and go and revel as

a princess. Yet, God was already working behind the scenes for her and others. Look at how God honored her with the most precious gift of a child:

"⁵And the daughter of Pharaoh came down to wash herself at the river; and her maidens walked along by the river's side; and when she saw the ark among the flags, she sent her maid to fetch it. ⁶And when she had opened it, she saw the child: and behold, the babe wept. And she had compassion on him, and said, This is one of the Hebrew's children. ⁷Then said his sister to Pharaoh's daughter, Shall I go and call to thee a nurse of the Hebrew women that she may nurse the child for thee? ⁸And Pharaoh's daughter said to her, Go. And the maid went and called the child's mother. And ⁹Pharaoh's daughter said unto her, Take this child away, and nurse it for me, and I will give thee thy wages. And the woman took the child and nursed it. ¹⁰And the child grew, and she brought him unto Pharaoh's daughter, and he became her son. And she called his name Moses: and she said Because I drew him out of the water." (Exodus 2:5-10, KJB)

I firmly believe that one of the most underrated blessings in a single season is the freedom to continually serve compassionately and selflessly. Reading through Moses' divine adoption story opens a fresh understanding of what it means to mother.

Just as God orchestrated this mother/son encounter, He can satisfy your desire to mother. There are several opportunities and ways to rear, raise up, parent, nurture, and mother the millions of motherless children. At the end of this chapter, there will be seven mother roles and

journeys that you can pray about walking in.

In the meantime, it's important to also prepare for motherhood, just as you are potentially preparing for marriage. This statement is not about the tangible physiological things that need to be done: a place for a baby to live, food, clothing, and the deep spiritual work that needs to be done in us as future mothers, to nurture and raise up a child. (2nd Timothy 3:15) Of course, little babies are cute, and your heart just melts at their tiny feet and hands and that new baby smell, but there's also a great responsibility given to parents by God (Proverbs 22:6, Deuteronomy 6:6-7).

Our first goal in the quest for parenthood should be that we are whole, not perfect. Whole enough to reproduce another one of us. Think about that: If you were to instantly become a mother right now, would you be okay with a mini-me? Not twinsies in matching outfits, but matching character. This is what happens when you parent. You are subconsciously reproducing yourself...your ideologies, your habits, your faith. It would be purely self-serving to fill your desire for love, acceptance, and happiness through a human and more so through a child. So, allow inner healing and deliverance from rejection, abandonment, hurt, and shame to fully take place before the Lord God blesses you to become a natural mother to your unborn children.

Even though finding Moses was a surprise to Pharaoh's daughter, it wasn't a surprise to God. I would venture to say He planned it. He divinely orchestrated this moment in time because He knew how she would

respond. He knew she would fulfill her assignment. When you think about it, Pharaoh's daughter was in the right place at the right time. Although this was a surprise to her, she graciously accepted this turn of events. Pharaoh's daughter tapped into everything that she had prepared for this moment beforehand.

A single season is a great way to prepare for the demands of motherhood. Practically, there will be food that needs to be cooked, money management, a healthy emotional environment in the home, time management, and more. I encourage you to focus on maintaining and sustaining these aspects of your life because they are just the basics of what's needed to live.

ALTERNATIVE WAYS TO MOTHER:

- Mentor a young lady from your community.
- Become a foster or adopted parent.
- Partner with a single Mom.
- Serve in the children's or youth ministry at church.
- Volunteer with a girl-serving organization

I remember reading about Katie Douglas a while ago. At the time, Katie had just turned 18 and visited Uganda on a mission trip. While serving in her single season, God spoke to her about becoming a mother. Only a few years passed before the 23-year-old adopted 13 girls from a village in Uganda. Yes, you read that right. Thirteen previously orphaned daughters had now found a forever home and mom in little ole Katie Davis.

Katie's story is remarkable. However, of all her

significant accomplishments, the most highly regarded success would be her "yes" to God. Whenever your season of natural motherhood begins, it would be destined for failure and strife without learning to say "yes" to God.

There is a grace for all women to mother. Alternative mothering options are not fillers, but they are a part of your God-given purposes. Your yes to God as it relates to an alternative mothering season of your life is a seed. It's a seed that needs to be planted.

Let's look at each of these ways from a practical standpoint. Ask the Holy Spirit: "Where do you want me to plant?" Remember, the scripture tells us that Pharaoh's daughter had compassion for baby Moses. Without knowing all the details of his past and only seeing his current condition, she called for a village of women to help raise Moses. What I'm trying to get at is we have no idea (unless Holy Spirit reveals it to us) what a child could grow into with the right nursing and nurturing of a Godly mother. You are that mother right now. Read below and ask Holy Spirit to help you see your role in these alternative mother roles.

Mentor a young lady from your community. This community can be where you grew up as a child or the current community where you live. You can do this organically if you have healthy relationships with your neighbors, or you can visit agencies like Big Brothers Big Sisters, and local school districts to request information about their mentoring programs. Of course, you'll want to connect with the parents and get their consent. As a mentor, I've learned kids just want

to be in your space. It's not about money or gifts. It's about time, acknowledgment, conversation, new opportunities, and friendship. Mentors guide and advise. They have foresight and oversight and seek to help navigate challenging spaces. Can you commit to being that advisor for a child? Not someone who thinks they know it all and won't let a child take their own journey, but one who can help that child continue to sojourn through the journey of life.

Become a foster parent or adopt a child. We all can agree that the U.S. child welfare system is painfully overpopulated. According to the latest data, there is over 400,000 youth in the system. While the goal and hope are for 55% of those cases to be reunited with the legal parent, the others are hopeful for adoption until they phase-out of the system through other means. No wonder the Bible presents these scriptures to encourage believers to take care of the orphans.

I'm not advocating for adoption to simply meet your needs of becoming a mother. Instead, I'm suggesting that one way to fulfill motherhood's call and assignment is by adoption. Just like marriage, it should not be entered into lightly or just because you can. Fostering or adopting should first seek to please God by meeting the needs of the child. It's more than Mother's Day gifts or the warm gooey moments we see on TV. It is a ministry that God takes seriously. If you're called to this area of ministry, I believe the Lord has already been dealing with your heart or will begin to. It's just a matter of timing, and when the Lord wants you to actively engage in the foster or adoption process, He will reveal it. Be open to hearing from God where fostering and

adoption is concerned. James 1:27 shows us exactly how God feels about it. Perhaps, like Pharaoh's daughter, you are one that He is calling to this position, even before or without marriage.

Partner with a single mother. Whether you have a desire to mother or not, there's nothing more Christlike than bringing help to those that are crying out in need. It's not difficult to find a single mother that needs help. They may not advertise it, but it's always appreciated. Parenting was meant to be a community/family job, not just for one person. Help could come in many ways. Everything from cooking a meal to babysitting to picking up kids from activities to helping with a birthday party or packing their kid up for college helps. This is a beautiful partnership, no matter what. Any way you look at it, all parties involved will come out on the winning side.

Look back at the story. Did you notice the village of women that intervened and partnered with Moses' estranged mom, even unbeknownst to her? It wasn't just Pharaoh's Daughter that showed up, but her handmaidens, a Hebrew nurse (doula), and even Moses' sister were all a part of his development. They were all his mother at some point in time, even his birth mother.

I phoned a single mommy friend of mine (a great one at that) and asked her perspective on this. She immediately began to share how my relationship with her daughters has helped when she desired for them to have a positive role model. She also spoke about the support that existed between her and other single moms. They would share tips, rides, meals, and more.

This is the type of sisterhood I believe we are to have. Whether you are a Godparent, surrogate parent, cool rich auntie, and everything else in between, there's no doubt that the child is going to be the one who benefits the most from this partnership.

Serve in children's or youth ministry at your local church. I must begin by saying, I know that children's ministry is not for everybody. However, as you grow in your desire for motherhood, you will also need to prepare to be your child's first teacher. This is especially true for the things regarding their faith and spirituality. Yes, that's right. God has a plan for every child. Consequently, parents play an extremely significant role in that plan. Nurturing and caring for someone else's child in a ministry setting is a colossal eye-opener. It reveals areas of your life that require more studying, yielding, and faith in Christ. How so, you ask? Let me tell you. When the Bible describes a child-like faith, it's not just for cars, homes, and material things. No, child-like faith is all about resting and trusting in Jesus just because... He said so. Seeing a young person soar in their faith really convicts you. Likewise, seeing a young person struggle and wrestle in their faith also deeply convicts you. You should be ready to have an answer for both. That's what my years of serving in youth ministries have taught me.

The Lord has had to do some deep work within me to cultivate and unlock this desire to have children and be a mom. I've always become overwhelmed at the thought of raising kids in the fear and admonition of the

Lord. The more I serve in youth ministry, the more I can see why He called my heart there. You will receive so much from serving even just a short time in youth ministry. They are always in need of volunteers, and you very well could meet that need. Be prepared to grow in the areas of patience, creativity, grace, compassion, humility, faithfulness, generosity, and so much more. This is a good starting point to learn what it will take to raise Godly children in the future. Consider it for a season or a lifetime. Either way, you are guaranteed to learn how to mother a young soul God's way.

Volunteer at a youth-serving organization or school. If volunteering in a ministry setting is a bit much for you, perhaps you would be more comfortable in a school or youth organization. They are always looking for volunteers for a variety of experiences. Many may find it easier to volunteer in this capacity because of a formal process or structure. The idea will be the same as volunteering in youth ministries; however, we should be careful not to proselytize the students we are partnered with. Instead of preaching, you might just preach with your love, light, and consistency. Either way, you can't go wrong. You'll get valuable experience and truly connect with the youth who need you the most.

When I was in my twenties, my spiritual mother gave me a prophetic word that left me shook. Through her, a spiritual mother, God declared that I would be as Sarah and be a mother of nations one day. I had no clue what to do with this, considering I was fearful about having kids in the first place. Here it is 18 years since, and I have yet to birth any children of my own. But I have.

See, I have children that I've helped to raise both spiritually and naturally. As an educator, an aunt, a community leader, a Girl Scout leader, a Sunday school, and a youth ministry teacher, I've got children all over. I'm not worried about them calling me "mama." I don't need to hear those words to know my purpose and role in their lives as a mother.

So you want to be a mom? Why haven't you? Some of us want everything to be perfect. We desire perfect circumstances because we have a sense of comfort tied to perfection. We think when things are perfect, there will be no rejection or no room for anyone or anything to be out of place. Well, let me tell you, God does not work or operate in perfection. How could He? If everything were perfect, what need would there be for a creative sovereign God?

If this hits you in your heart, you're the one I'm writing to. Stop trying to be perfect or get to the ideal place in your life or make things perfect along your journey before you get to your destination. No matter how hard you try, it will never be perfect, and that is okay.

When we look at these alternate ways to mother, it's vital to understand that the purpose is bigger than you. Motherhood is the most selfless and sacrificial act a woman can agree to. For some have lost their lives, both physically and figuratively, to become a mother. That's why there is an appointed time for your natural motherhood to occur.

If you think about your strong desire when you read

this chapter, then I beg of you to consider, dream, and pray about if one or more of those alternative mothering gifts (options) could be for you. They could be for now or for later, so be sure to ask God when. Not when you'll be a mother, but when you need to step into this grace over your life. That time could be sooner than you think.

Reflection Questions

What can you take away from Pharaoh's daughter's brief experience of motherhood?

What is the legacy you desire to leave for your children (biological and/ or spiritual) and grandchildren?

<u>Worship</u>
"Love Has a Name"- *by KJ Scriven*

<u>Prayer</u>

Dear Lord,

We thank you for the supernatural ability you bestowed upon us daughters to mother. Thank you for breathing into us the capacity to love, nurture, and guide children. Allow me to trust you and your perfect timing for the moment in time when I will mother. Lord, since it is a prepared and appointed time, help me wait with patience and peace. If you see fit, give me an opportunity to mother the motherless in schools, churches, abroad, and within my very own community. Fulfill my desire for motherhood in divine ways. I surrender my will for yours and believe that you are preparing me for the ministry of motherhood. Teach me how to sacrifice, encourage, cover, and protect the children you have and will place in my life.

In Jesus' Name, Amen.

7 LYDIA
ACTS 16:14-15, 40

Lydia's story in the Bible is not even a whole chapter long. Sometimes we get stuck on the heroes and sheroes of the Bible. We forget that God desires to use the small no names all the way up to the "headliners." With God, there are no insignificant, purposeless, and anonymous people.

This was Lydia's place. She is introduced in the Book of Acts. Though her appearance is small, her impact leaves a lasting impression. What impresses me time and time again about Lydia's life is her holistic work-life balance immersed in a life of worship. Yes, we often hear a great deal of Lydia's business skills, forgetting about her hospitality and consecrated livelihood. Let's spend some time looking at the lifestyle of this born again #girlboss.

Lydia is considered to be the first recorded convert to Christianity in Europe. She was from Thyatira. The Apostle Paul records their introduction in the 16th

chapter of Acts. Paul and the other disciples were journeying along to the next destination on their route or preaching tour. It is believed that in Paul's original destination of Philippi, there were only ten holy (or Jewish) men around to provide the requisite quorum to form a synagogue or formal place to worship. That part… #wherearetheholymen?! I digress.

Somewhere along the journey, the Holy Spirit prompted Paul to make a detour and head to Macedonia instead. So instead of a church, they went to the river to pray and preach. On the Sabbath, Paul went to the river to pray, and who did he find? A group of women. And who was in that group of women, you ask? Our dear sister Lydia, that's who. Lydia was likely drawing water for her household when this encounter happened. There's something about women being at the well...at the place that never runs dry… selah… carry on.

As Paul and his companions began to teach, Lydia began to listen, and her heart began to respond. Two scriptures come to mind when reading her story.

"Jesus said unto him, Thou shalt love the Lord thy God with all thy heart, and with all they soul, and with all thy mind." (Matthew 22:37, KJB)

"So then faith cometh by hearing and hearing by the word of God. (Romans 10:17, KJB)

Let's deal with the first scripture. Loving God with your heart, your mind, and your soul seems quite simple, considering it's just a few words. What people

fail to realize is that love is not a passive word, but it is indeed an action. Love has movement. Love has a sound. Love reverbs.

When I look at the sentences surrounding Lydia's appearance, the part that caught my eye was verse 14, where it merely states that she was (already) a worshipper of God. Lydia worshipped God before anything. The scripture later says that she and her household were blessed and that she opened her home to Paul and the others who were traveling with him.

Beloved, I'm here to tell you an authentic truth. If you don't become a worshipper and a lover of the things of God during your single season, you are going to have a tough time thriving anywhere else in life. I believe worship is the passageway to the presence of God. Everything we desire in a spouse is found in a lifestyle of worship. Let me say that again because I think I surprised myself. Everything we want in a spouse is found in a lifestyle of worship.

In my almost twenty years of walking with the Lord, I've come to observe that we as Western culture believers tend to reduce worship to an isolated moment apart from a specific event. We say we worship during the slow melodic songs in a 60-minute praise and worship set. I'm writing this chapter of my book during the COVID-19 pandemic, and I can't tell you how many posts I've read that stated, "I really miss worshipping God," as if the God we worship is sitting all by His lonesome self in our church buildings.

If there is no other time in your life to learn the tune

and fabric of worship, it should be as a single person. Worship is not just reserved for Sunday services. It's not a privilege for those of us who are more emotional or for your favorite singer. Worship is the tendon of our faith in God. Let me attempt to help you see this clearly.

A tendon is a flexible but inelastic cord of strong fibrous collagen tissue attaching a muscle to a bone. When I think about elastic, I think about my favorite pair of leggings. They're my favorite because well, you know… ice cream. Ha! It's true, though. They are my favorite because I look good in them and I feel good with them, and most importantly, I bought them on clearance…from Dollar General #Winning! #Budgetista! They have grown with me. The elastic allows them to stretch and return to their original state. I'm always baffled to see just how much Mint Chocolate Chip can fit into these things! Anyhow!

Even though I'm a fan of being able to ALWAYS fit these leggings, I have to say that I was quite frustrated when I realized that they were losing their shape in other parts. You see, over time, the elastic began to wear out, and the leggings kinda lost their appeal. If you've ever tried to bunch all your beautiful, glorious hair into an elastic hair tie or rubber band, you know that elastic can break. We think it has more capacity than it actually does. Tendons are not elastic, but they are flexible. When something is flexible, it is capable of bending easily without breaking. Other words for flexible are adaptable, open, fluid, forgiving, and cooperative when describing a person's flexibility.

Think about this: tendons are flexible, forgiving, and

adaptable strong tissue that attaches a muscle to a bone. What am I saying? A lifestyle of worship strengthens our muscle of faith so that our faith can attach to God, our bones, our structure, our foundation. Don't call me a blasphemer. Go with me to Physiology & Anatomy 101.

Bones are assigned to do the following:

- Support the body.
- Facilitate movement.
- Protect internal organs.
- Produce blood cells.
- Store important minerals.

Singleness is that time when our lifestyle of worship is put to action. We have time for it. We have a desire for it. And we have access to the God we worship. Lydia was not yet baptized, but she knew of worship. Her worship to God opened her heart to hear the word of the Lord and ultimately saved her and her household. That is major. What is your worship securing for your future during this time as an unmarried woman?

When we live a lifestyle of worship, we will begin to see and know who God is, which will provide an image framework of the husband God desires for us.

But what you must appreciate about our girl Lydia is that she wasn't worshipping God because that guaranteed her a husband. In fact, Lydia was a Gentile. She didn't know God before this moment. But she wanted to know Him. As she worshipped God, the Bible says as she listened to Paul preach, her heart was

opened by the Lord. The Message version puts it like this:

"As she listened with intensity to what was being said, the Master gave her a trusting heart -- and she believed! ~ Acts 16:14.

It is incredible what a lifestyle of worship can do for you. It can change ordinary, everyday moments into divine moments in time that have promise, opportunity, and purpose behind them.

What we typically know about Lydia is that she sold fine linen. We know her as a #girlboss and a #womanpreneur. This is certainly a message for every woman with an entrepreneurial destiny over her life. More than any business course, or networking event, or pitch competition or negotiation meeting, your worship --that devotion, intense reverence, and obedience to Christ-- has to be a top priority in your life. If your business gets in the way of you being 100% devoted to God, you need to shut it down until your priorities are back in the right place. I know you think you can do both, but the Bible is clear when it states thou shalt have no other gods before me.

You see, sometimes, as single women, we allow our possessions, or business savvy, careers, or success to be the thing we worship. We figure if we pour ourselves into that, then we won't have time to be lonely and want for a man that we can't seem to find anyway. So, we dive headfirst into building a brand instead of diving first into God. Neither one of these situations please God.

I'm not saying that God doesn't want us to be businesswomen. I am saying God doesn't want that business to come before Him. It should glorify Him. It should accomplish what He wants to see on the Earth.

Lydia had to be somewhat successful, considering she had her own home and servants. In all of this, she still made time for God and found herself in the place of prayer. It was there that God met her. Theologians believe she could have been a widow or single because she was the head of her household.

Lydia is mentioned later in the chapter after Paul is released from prison. After her conversion, Paul and his companions stayed with Lydia for a few nights. She was hospitable and availed her home to ministry. Lydia opened her house to Paul twice, which shows she truly knew how to love her neighbor as herself and believed the message of the Gospel.

The beginning of verse 14 reads like a short bio:

"And a certain woman named Lydia, a seller of purple, of the city of Thyatira, which worshipped God, heard us:..."

This list, I'm sure, could have gone on and on forever. Certainly, Paul knew Lydia quite well, but I'm amazed at the things he offered to report about her. Yes, she was a businesswoman; a successful businesswoman doing quite well, actually.

It's true, Lydia came from a very wealthy region, so

much so, that she was able to sell her goods, exquisite, purple-dyed linen, in an entirely different region. All that is impressive, but what impressed me the most are the last two points this scripture hits: she worshipped God, and she heard the message of the Gospel.

Wouldn't you love for people to read this list about you instead of everything else? It didn't say she was a businesswoman and a widow. It didn't say she was from a wealthy town but single. No. None of that mattered. What mattered is that she was handling her business, she worshipped God, and she heard through active listening, the message of the Gospel.

God blows my mind every time. Paul wasn't even going in this direction on his missionary journey, yet here was the moment that Lydia had been longing for. That should encourage you that God knows exactly where you are and will change others' plans to ensure that you get what you need most: Him. I'm so glad Lydia was at the well with a group of women praying. I'm happy she wasn't too busy with her business or too frustrated with her loneliness or so fascinated with her success and pedigree that she missed the moment to experience real intimacy with God.

That's a beautiful part of our single season that I probably enjoy the most… the presence of the Lord is so accessible and readily available to us. Sometimes, my married friends come to hang out at my house to have that moment again. We must learn to value the sweet communion and uninterrupted fellowship that we get to have with God. When nothing else satisfies us or soothes us, He does.

Because of this moment in time, the story of Lydia is penned for eternity. Aim to be a faithpreneur, a worshipper, and to have an open heart towards God. For when we do this, He gives us everything we need.

Reflection Questions

What three things do you desire from God the most?

What things have you put before worshipping God and inviting His presence into your space?

What do you need in order for the Lord to "open" your heart?

What skill or talent have you discovered through your single season? Is this potentially a new stream of income for you?

After reading Lydia's story, how might your idea of biblical hospitality change?

Worship
"Here Again"- *by Rheva Henry*

Prayer

Lord, thank you for the way you orchestrate divine connections and introductions. I invite you not just into my life, but into my heart, to be the Lover of my Soul. Father, there are many people that I love and many things that I love to do. May I always employ the Holy Spirit to manage my time so that I am fully available to worship you and obey your voice. As you grant me favor and influence in my profession and business, it will help me be integral, industrious, generous, and humble. At the end of the day, I wish for nothing to stand in between my devotion to you. I submit my plans to you now and declare that you are Lord over every part of my life.

In Jesus' Name,
Amen

8 SAMARITAN WOMAN
JOHN 4:1-26

The story of the Samaritan woman is often preached from a perspective of condemnation. We know her sin. We know her faults. We know her past. We know her shortcomings. The one thing that I find interesting is that we don't know her name. Now, this is not uncommon in the Gospel of John. Many of John's accounts of Jesus' interaction with strangers go nameless. We don't formally know why John does that. However, I love the fact that we can insert our name into this woman's story.

You may be offended. Thinking that I just slapped you with the label of adulterer, a lady of the night, loose woman. Well, that's not what I mean. When I think of the Samaritan woman, I think of what she was longing for: Acceptance and love. Her hidden identity allows us the opportunity to experience and encounter Jesus just as she did. We can now receive the healing, filling, and revelation from her moment at the well.

Acceptance and love are vital life complexities that every human longs for, whether male, female, young, old, single, or married. It's the way that God wired humans so we would first, acknowledge the need for a Savior, and second, cultivate healthy relationships amongst each other. The Samaritan woman speaks to us when we are feeling unworthy and unloved. Her past was filled with much heartbreak, disappointment, rejection, shame, hurt, low self-esteem, and abandonment. Her greatest desire was to be loved... and there is nothing wrong with that. We were created to love and to be loved, so it's no shock that the Samaritan woman spent several years searching for this love. Sidenote: I find it strange that the one thing that everyone needs and desires is so hard to find and even harder to accept once found. This is what years of hurt will produce.

The Samaritan woman encountered the love of Jesus on a perfectly normal day. Totally unexpected and unplanned. She was just doing what she always does.

In her story, the Samaritan Woman begins to question Jesus. I love these moments in the Bible, where a real conversation is exchanged with Jesus. It further illustrates His accessibility and authenticity. In the next few pages, I'll do my best to pull out the fundamental components of this interaction to illuminate the love and acceptance we receive from God.

1. Jesus will go out of his way to express his love towards us. On the day that the Samaritan woman had this encounter with Jesus, nothing seemed out of the

ordinary. She would fetch water like she always does at about the same time she always did and take the same route she had always taken. She wasn't necessarily a predictable woman as she was stuck in a pattern of negativity, hopelessness, and insignificance. She knew that road all too well. Can you just imagine her dismay when she gets to the well and sees a man sitting there? It was nothing that she planned, but all a part of God's plan. So much so that Jesus himself intentionally broke customs and traditions by traveling in the way of Samaritans. This was out of the norm for Jews, but it shows the chase that Christ has for us. Simply put, we are always His first choice. We're not His backup plan or afterthought.

As an unmarried woman, this can be a hard pill to swallow because of previous romantic rejection. We wonder if we're God's first choice, then why haven't we been chosen. Based on the Samaritan woman's encounter with Christ, I'd suggest that it's all about timing. There is perfect timing that has been established in God's time where you'll be chosen. Until then, there is an extraordinary work that God has called you to, and you're the only one that can do it. This leads us into the next component of the accessibility and authenticity found in this encounter.

2. Jesus will engage us with genuine intimacy and reveal to us our actual value. What is beautiful about the Samaritan woman's encounter with this man (because she had not yet known He was the Messiah) is that though she met Jesus empty, she left His presence with the fullness of joy and forever filled with His love.

It's crucial in our single season to understand that God is relentless in his pursuit of us. And unlike some of our male counterparts, He's not chasing us just for games or a one-night stand. His chase is for one purpose: An intimate relationship. You can take to the bank that our relationship with Jesus will be the most fulfilling and life-changing relationship we will ever enjoy.

Despite the Samaritan woman's multiple relationships, she had never truly experienced intimacy and purpose within them. We see this in John 4:15:

"Sir, give me this water so that I won't get thirsty and have to keep coming here to draw water." (NIV).

This is one truth that keeps me going when I feel alone, empty, and long for the intimacy of a romantic relationship. My plea to God is to give me this water so that I won't get thirsty and have to keep coming to this place to get more. It is an alarming reminder that no one --not even my future husband can fill me up like Jesus can.

On most days, we enjoy our singleness and don't really think twice about a lonely night or two. Then there are other days when you desire the embrace and deep connection that an intimate relationship produces. Intimacy is not only physical and sexual closeness. We know this by the interaction between the Samaritan woman and Jesus. Even though Jesus walked this earth fully man and single, his encounter with this woman (and others) is meaningful, pure, and liberating. That's what interacting with the presence of God feels like.

Suppose you're an unmarried woman engaging in sex as a means of seeking a feeling of intimacy. In that case, I encourage you to pray to God our Father to begin to think differently regarding these experiences. I know that we're told to pray these yearnings away, but that's not what I'm saying. I encourage you to pray to reveal what's really going on in your heart. All behaviors, feelings and emotions have a root cause. That's the thing we want God to deal with the most.

The Bible tells us that our bodies are temples or sacred houses for the Holy Spirit to dwell in. While engaging in sexual relationships may release feel-good hormones for the moment, they don't last long. Furthermore, they don't compare to the lasting intimacy with God the Father. I know many of you know this. However, God wants us to live and walk in this until we marry. The purpose of our purity is not just to deny ourselves now, but it is also to purify our marriage bed and sexual intimacy with our husband.

This is why the Samaritan woman's encounter with Christ was so memorable. This moment was truly mind-blowing. Jesus was really showing His divine character when He said (in so many words), I'm so much better than all-- any man that you've ever had. If you let me, I'll satisfy you forever.

If you're an unmarried woman who does not have sexual relationships anymore, I want you to know that the tangible presence of God never gets old. My encouragement to you is that you also pray. Pray that you would request and acknowledge a way out when

you are tempted. God wants you to know that He sees you. He sees that you are committed to the vows you've made. He sees you in the moments where you quickly figure out what to do with your sexual urges. Hang in there. He is going to meet you when you need Him the most. His grace is sufficient for you.

Finally, to the woman that's a virgin. Your time is going to come sis. If anybody knows, God does. There are some things that you dare not even speak, because of what people might think or because you're afraid of where it could lead. Trust me, I know. God wants you to know that it really is going to be worth it.

There have been times when I wanted to risk it all and ask for grace later. I've verbally renounced my virginity a few times because in the moment, my body naturally wants what it wants. I've prayed, *Lord, am I going to die a virgin? How come others get to enjoy this experience and not me?* And then I've had to repent. Deep down, I know that regardless of whether I die a virgin or not, I want to please God. I don't want to lose the opportunity to honor Him, by enjoying (or not) sin.

I've experienced moments of frustration and loneliness many times, and these natural human moments intensified my desire for sexual and emotional intimacy. Though a healthy and natural desire -- and one given by God himself -- I had to learn how to give that part of me to God. It required nakedness and vulnerability. Practically speaking, there was an atmosphere and mood to set and a determination to gain. I had to plan some moments and learn to be spontaneous. In those moments is where I begin to give

my heart entirely over to Christ. The presence of the Lord has literally disrupted my pity party in the middle of the night, just to express His love for me. My tears of hopelessness and despair became tears of worship and surrender to the Lord. That's the beauty of real intimacy with the Lord.

Learning to love Him and allowing Him to love us is the most intimate act we'll ever experience. When we get to that place in worship, we are open and unashamed and safe to hear His truth and accept His love.

There never has been, nor will there ever be a walk of shame after spending time with the Lord. You won't feel that guilt of disappointment. You won't feel empty moments later. Yet the hope, joy, and fullness you receive, you won't want to keep it a secret (John 4:28). You'll no longer need to fill your heart with empty relationships, sexual fantasies, and fleeting experiences.

3. Jesus will pour into you when your heart is open. Have you ever seen a cup overflow? How about a trash receptacle? Maybe you've had an unfortunate bout with an overflowing toilet? Most times, an overflow is quite messy. It always requires a "cleanup on aisle 5." Once the spill is cleaned up, we start back at step one. Sometimes we wonder what caused such a mess, not realizing that the object was already filled to capacity with another substance. Now, we carefully pay attention to how we utilize and handle the object to avoid another mess.

In verse 16, Jesus asked the Samaritan woman to go

get her husband. Don't you think it quite strange that now there is a "need" for her husband? What's the point, right? What did her husband(s) have to do with anything? I'm glad you asked.

What if Jesus called for her husband as a way to identify every blocked space in her heart? Every relationship continued to fill her with shame, despair, rejection, and hurt. Though she gave her all to each husband and met their needs, not one of those men could satisfy her longing and need for the living water.

I believe her husbands could also reveal to us the things we place as figurative husbands in our lives, limiting the access we give to God to fill us up. Think about this: our husband will be the man with whom we date, share our love, energy, and devotion. He will be the one with whom we spend time and build intimacy. Since we don't yet have a husband on the books, we make other tangible or intangible things our husband. For example, chasing a career, keeping up with image and status, getting as many social media likes as possible, inundating our eyes and ears with Hollywood imagery, and more. We don't even realize that our "love" and "chase" of these things have landed us in a place of idol worship. Idol worship is when we replace and misplace our devotion to God. It is usually quite subtle and slowly turns our attention away from our Creator.

Have you ever fasted before? I can recall a time when I fasted from social media. At first thought, the idea of detaching from mindless scrolling, laughing at someone's random meme, and filling my head with

extremely basic information seemed like an easy task. I knew that it would be a no brainer to give my former social media time back to God. Quickly, I realized just how much social media had become an idol for me. And when I picked up my phone and realized I had deleted my app in an attempt to be intentional with spending time with God, I still neglected the nudge from Holy Spirit to pray or worship or at least read a scripture from the Bible App. The irony is that I was thirsty to connect but had no idea that the primary connection was on my knees in prayer.

I can't tell you what you may have in your life that is covering up a hole that you desperately want your husband to fill. I can't tell you what the secret formula is to balance faith and your waiting season. There's a fine line between waiting for God's promises and worshipping the promise before you worship God. Remember that God's promise should never replace our devotion to God. What I can tell you is that Jesus is somehow enough. It's a miracle to me how one moment I can be lonely, despondent, and downright pitiful, then moments later, after tears, prayer, and worship, I can boldly testify that Jesus is all I need- and actually mean it. Soon you'll realize that Jesus' love comes from a well that never runs dry. Not only is His love free flowing, but that well the Samaritan woman stood at was deep. I mean deep, deep.

Ephesians 3:12 puts it like this:

"In him and through faith in him, we may approach God with freedom and confidence. I ask you, therefore, not to be discouraged because of my

sufferings for you, which are your glory. For this reason, I kneel before the Father, from who every family in heaven and on earth derives its name. I pray that out of his glorious riches, he may strengthen you with power through his Spirit in your inner being, so that Christ may dwell in your hearts through faith. And I pray that you, being rooted and established in love, may have power, together with all the Lord's holy people, to grasp how wide and long and high and deep is the love of Christ, and to know this love that surpasses knowledge-- that you may be filled to the measure of all the fullness of God."

Paul had to pray this prayer for the Gentiles. I can hear Paul writing this letter from a jail cell, mind you, passionately communicating that there's so much more to what we have already experienced in Christ.

Sometimes that midnight loneliness sneaks up on you. Sometimes those hormones come out of left field. Sometimes the desire to find satisfaction in Christ and Christ alone seems like a fairytale. All that may be true. In the same breath, it is also true that there's more to Christ than we know. So, the way we long and dream for the man of our dreams should also be the way we long for Christ. We're missing out on the good stuff, giving most of our energy and mental capacity to our idols.

So, open your heart, beloved. As Jonathan McReynolds says, "Make room."

Will you commit to that? Making room for the expanse of God in your life? We know that married

women won't have this option as freely as we have now. We don't want to get to our married season and wish for singleness all over again. Let's make room to know just how wide, deep, tall, and big the love of GOD is. He's at the well waiting for you.

Did you know that Isaac, Jacob, and Moses all found their wives at a water well? I didn't either. It's kinda one of those details you never really paid attention to in their monumental stories. When I discovered this truth, I began to wonder, why the well? What's so special about that place, and quite honestly, where can I find one of those wells today? Then Holy Spirit gently reminded me that the well is the place people go to get an essential life component. Water. The well is where people go when they need the one thing that will quench their thirst and satisfy their needs. It's not coincidental. Go to the well. Take that journey with Christ into the deep places of your heart and let him satisfy every need that your soul will ever have. Meet Him at the well.

Reflection Questions

What are the things you find yourself thirsting for? How do you know?

What would it look like for your thirst to be quenched in all these areas?

What are three actions you can take that allow God to pour into your life?

Worship
"Isaiah Song" - *All Nations Worship Assembly Atlanta*

Prayer

Father,

Thank you for satisfying me and quenching my spirit. Your love has always been the never-ending well, and it's still flowing to this day. Even though I have been thirsting for the superficial and fleeting desires of this world, I know that you are the only thing that can satisfy me. I receive all that you want to pour into me. I empty myself- my heart, will, emotions, and plans and I say fill me up.

In Jesus Name,
Amen

9 YOUR STORY

Your unmarried season prepares you for your purpose and assignment on Earth. For some, marriage is a part of that assignment. Don't fear this season, but DO everything that God has placed on your heart to do. Don't let the fear of becoming too successful, too wealthy, too healthy, too (insert here) keep you from obeying God.

There was a point in my life when I literally said all the things that I didn't want to go after unless I had a husband. Travel, buy a home, expand my business, and worst of all, get too busy in ministry. I now realize that it was all fear. I had to repent for that vow I made. God showed me it was rebellion. Under the banner, disappointments, laziness, inadequacy, anxiety, and disobedience to my Creator, God revealed to me I would be out of His will, which scared me more than anything. God showed me that what I do in my singleness only enhances my marriage.

My spiritual father, Pastor Sean Holland, put it like this: "The longer the preparation, the better the execution."

When I first heard him say this, I was taking a 12-week course to launch my bridal business, so that's where I applied it. After some time passed, I realized that this simple expression was the golden nugget needed to endure several seasons of waiting. You see, there's a purpose to our waiting, and the purpose is the wait. I struggled with this word for such a long time until I began to study it through the lens of the Holy Spirit. I found that several biblical figures, many of whom we read about in this book, were top-notch examples of what it looks like to wait healthily. This is quite taboo in the hasty, instant gratification generation we find ourselves living in.

What is it about waiting that instantly offends us? Don't you think it strange that the things that taste the best, look the best, and function the best are things that take time? Someone or something had to wait for one specific part of the process to be completed. This is what I'm learning about waiting, especially when it comes to my singleness. Now, I'm not saying this to fluff you or even try to comfort much of the longing and loneliness you can sometimes feel. I've had to get open and transparent and expectant with God. While I'm waiting, I've got questions. What is this like? What will I need this lesson for? Who will need this overcomer's testimony in my future?

THESE THREE WORDS:

I love you.
You are beautiful.
You look amazing.
Dinner is ready.
Bills are paid.
I got this.
You're all mine.
Thinking about you.

Haven't we all wanted to hear these three-word phrases? Who would have ever imagined that three little words could change your mood, encourage your spirit, and brighten your day? On the contrary, if they can do all this, then they would have the potential to cause significant harm as well.

The book of Proverbs is filled with simple words of truth, advice, and pure wisdom. From it, we can glean so much about our character, our relationships, and life in every aspect. Here are some proverbs that highlight the significance of our words.

Proverbs 15:4: "Gentle words bring life and health; a deceitful tongue crushes the spirit." (MSG)

Proverbs 16:24: "Kind words are like honey-sweet to the soul and healthy for the body." (NLT)

Proverbs 12:14: "Wise words bring many benefits." (NLT)

Proverbs 12:18: "The words of the reckless pierce like swords, but the tongue of the wise brings healing." (NIV)

Proverbs 16:24: "Gracious words are a honeycomb, sweet to the soul and healing to the bones." (NIV)

Proverbs 25:11: "Like apples of gold in settings of silver is a word spoken in right circumstances." (NASB)

Proverbs 31:26: "When she speaks, her words are wise, and she gives instructions with kindness." (NLT)

Matthew 12:36: "But I tell you that every careless word that people speak, they shall give an accounting for it in the day of judgment." (NASB)

It can be difficult as a single person (not just women struggle with this) not hearing any combination of those three words I mentioned at the beginning of this chapter. You may be like me and come home to an eerily quiet, empty house and long for someone to miss you. If you've been living this single journey for some time, you may not have always heard the right three words. It's likely that you've heard rumors, stories, and comments that have been hurtful, criticizing, and even demeaning in some way. If that is your truth, know that you have the power to break whatever words and curses have been spoken over you in this season.

I'm willing to bet that the words or phrases you probably have heard and internalized as an unmarried woman have been something like this:

You're not ready.
Work on yourself.
Be more content.

Just keep waiting on God.

I know, sis. If I hear one more time, "You're not ready." Yes, I've been there a time or two, or thirty. Nervously, I asked the Lord what He thought about these words. "God, do you really think I'm not ready to be married?" His response? Write the book!

For years, I felt like God wouldn't respond. This taught me that even the ones who love you will have a lot to say that's probably not what the Lord is saying. Sometimes, people feel like they have to have an answer and response. When the Lord was quiet, I knew that He would show me the answer to that question in a different way.

I approached Him once more and said, "God, I'm tired of hearing these words. I'm tired of others speaking them over me and, even worse, speaking them over myself. God, I need you to show me what this means for me." And He's been doing that ever since.

The three words that previously deflated me and crushed my hope are:

PREPARED~ READY~ WAITING

If you will, allow me to share some spiritual acumen with you that has helped me be ok with these three words.

Prepared: I learned that in ancient Jewish customs, wedding dates were set loosely. This wasn't because of the possibility of there being no wedding due to the

Groom's cold feet or a case of the runaway bride. Instead, wedding dates were usually communicated just days before the actual event to ensure the family had enough time to prepare all the details for the big event. That's right. Can you imagine getting a phone call on Monday to request your presence at the most significant life event of all? It's unreal, especially in today's society, where wedding planning and engagements can last multiple years. Not only would the guests be waiting, but could you imagine what that did for the Bride and Groom?! I mean, at this point, they just wanted to be married already. However, there's a significant point to be understood in all this. The preparation is just as necessary, if not more important, than the actual event. Perhaps it's not even that the event is important at all, but the preparation. When the final preparations are made, then an official wedding date is released.

Let's be honest here; When we prepare for something, we know it's going to be right. It could be as simple as picking out your clothes the night before, meal planning before you hit the grocery store, or even mentally preparing for a gruesome workout. It is unrealistic and overwhelmingly impossible to think that you can prepare for an event as the event is going on. That type of mentality is exhausting, inefficient, and a recipe for disaster without the grace of God. Preparation is a mixture made for a particular use. It involves several components, ingredients, or steps to make ready.

Preparation is really an act of faith. You see, there's really no point in preparation for anything unless you believe it's going to happen. Why do people go to

college? Because it's a part of the necessary preparation to graduate and secure the job of their dreams. Why do we make shopping lists for Thanksgiving dinner and Christmas gifts? Because we know the event is coming, and if we fail to prepare, we can run the risk of forgetting someone, going over budget, or getting what's leftover and ran through. Why do people meal prep and plan? Because if they don't, they are more likely to jeopardize a lifestyle change/diet and/or compromise their food budget, amongst other things.

Confession: I start packing for a trip weeks in advance. No seriously! The excitement of traveling, vacationing in a new state or country gets me soooo excited. Everything I do becomes about "my trip." I prepare by budgeting, researching cool places, outfit planning, putting in my PTO request, and then my suitcase comes to the front couch wide open, ready to receive. #SheReady!

I had to learn this the hard way. You see, your girl is FORGETFUL! I mean, I forget that my glasses are on my face, so imagine being miles away in another country, and you don't have any of your toiletries and hair care products. Yes, that was me. I'll spare you the details, but let's just say I was forced to do a big chop and returned home to my hairstylist with quite a challenge—lack of preparation. I just assumed that I'd be able to get what I needed once I got to my destination.

That preparation is more key than we care to admit.
In fact, I believe preparation or practice is more like an investment. It's something that we do now to secure

and hope for the future. It will require discipline, sacrifice, hard work, being misunderstood, and taking risks. This is a process that many may begin because of the promise at the end. But honestly, I haven't found anyone yet that loves going through their preparation process.

I believe the enemy uses hopelessness and disappointment to abhor and ultimately forgo the preparation processes for what God has for us. Whether we've said it out loud or not, we may have thought, "What's the point in preparing? I'm never going to _____ anyway?" Or "What's the point in preparing now? It'll be weeks, months, maybe years or God forbid, decades before I _____."

I was there many times, and honestly, it's a daily fight to remind myself that I have a choice to prepare for my future, even though I can't see it. Not only in a literal sense, but even in my faith. There are simply moments (it used to be days) when I struggle to believe God's promises to me as an unmarried woman. This is not just about marriage.

There are so many other promises beyond marriage that God wants us to prepare for and be prepared for. Promotion, open doors, opportunities, hardship, death, disasters, and even pain needs a plan. It needs your investment of time to prepare for it because it is inevitable. Thinking back to what we learned from Orpah's account, we have to make choices. As a born-again believer, you are empowered with God's wisdom to make life be what you want it to be.

I am challenged every day to actively prepare, not just for marriage, but for life and for my God-ordained purpose because it's a direct reflection of God's character. I mean, who else can we find that is a master planner and hands down the best at preparing? Isn't it something that God knows the future and was still diligent to make preparations? I'll prove it by sharing one of my favorite New Testament scriptures.

"⁹But as it is written, Eye hath not seen, nor heard, neither have entered into the heart of man, the things which God hath prepared for them that love him. 10But God hath revealed them unto us by his Spirit: for the Spirit searcheth all things, yea, the deep things of God." (1 Corinthians 2:9-10, KJB)

Think about the fact that God not only has a plan but diligently prepared for all eternity as well as the present day. No shade, but God wasn't just sitting in Heaven twiddling His proverbial thumbs. Without getting too deep, God is not controlled by time either. It's important to know that these preparations were made long before we got here.

I absolutely LOVE this about God's character. His systems and ways are methodical. Psalmist Naomi Raine put it like this: "We've got the best deal in the world." It's so true. We are direct beneficiaries of a God who planned us, prepared for us, and invested everything He had into us.

This is the mind I want to embrace as I prepare for my future. I don't want to get to that place and then tell myself --or the people depending on me-- whoops… I

didn't think you were coming so I didn't prepare anything. I don't want my legacy and all that God has put into it to suffer because I failed to plan.

Then you may decide that you are prepared. To that I would say, "Girl, keep on preparing with your bad self!" Seriously. Why limit yourself? What else can be done? What else can you do? If you've stopped preparing, I will venture to say you've stopped dreaming, hoping, and believing. God will be the one to announce the date of your promise so until then, don't get prepared, but stay prepared. Tuck away what you've already done and learned, and then go prepare for something else! Listen, God's plans for you are HUGE. The moment you feel like you've conquered it all is the moment that you set yourself up for hopelessness. Keep going, sis. God's word over you is extensive. Believe that.

Ready: This is not only about being ready to be something, but is time ready for what you are about to become? Is your assignment and calling for this season ready to respond to a version of you no one has ever seen before?

Truthfully speaking, "ready" was my personal death. This would crush my spirit. I couldn't understand how I was not ready for a relationship-- no, for marriage and to be a wife. You mean to tell me year after year, I'm still not ready? Altar call after altar call, I'm not ready? Then my pride started to fuel these rants, and I began to tell God about all that I've prepared, accomplished, and sacrificed. I even told God it was His fault that I wasn't ready. Oh yes, I've been quite upset at this word. I

begged and pleaded to the Lord to make me ready. I had done all that I could do and simply said, "It's above me now." Hear me: I was not content. I was tired.

It was at that point when this word started to make sense and restored my hope. The fact is, I'm not ready. The purpose and destiny God has for your life are weighty. We can't even fathom it. Even though we can prepare for it, we still won't be fully ready for what it brings when it comes. This doesn't mean that we do nothing, of course. We just read that in the section above. What I'm saying is simply some things are out of your control. The preparation part is for what you can control. The ready piece, I've learned to leave it up to God. Here's what He showed me: My preparation (the work that I do) is getting me ready for it.

Similarly, the preparation that God has made (not making) is getting it ready for me. I hope you caught that. Reread it... slowly...

Remember that promise that God made to you? Did you know there is an appointed time for it? Yes, He has revealed it to you and shown you bits and pieces of it because you needed the hope and encouragement to begin preparing. But everything that God does has a specified time. I don't quite understand it, and maybe you won't either. It's called sovereignty. I want to pause prophetically and speak over every person reading this book, that you will not miss your moment and your time in Jesus' name. (You can say this out loud over yourself as well. You have the power to do so. Remember, it's your choice. Say it loud and say it often. Trust me, it helps.)

What God has prepared has a plan for it. When we don't see what God has shown us, it could be for a couple of reasons. I've learned to hold on to that. Where I am in my life right now does not require me to have obtained that position in my purpose. And I've learned to be ok with that. We'll talk more about it at the end of this chapter, but just because you haven't acquired something or some status does not mean you are unloved, forgotten or that something is wrong with you. Our earthly schedules and societally driven timing make us think that, but it is just not true. While I write this section, I am still unmarried and boo-less, but I am not purposeless! For the first time, in a long time and maybe ever, I am actively living a purposeful life.

This was the whole point of this book. In the church, we've learned that we only have significance once we are married. No! One day while driving to work, I heard the Spirit of the Lord communicate a hard truth. Loud and clear, the Spirit said, "You don't need a husband right now."

Say what?
I beg your pardon?
<u>Oh no! I rebuke you, Satan! LOL</u>

But I didn't rebuke Satan because I KNEW that was God. Oh, my goodness. I felt the hurt and pain of the Father. It's like He was annoyed with me because all my prayers, tears, and requests were for a husband. I had to park my car in front of my job, turn off the radio, and just listen. Oh, man. Sis, I wept. I'm crying right now just thinking about it. I'm weeping for you because I

know what it's like to be told how ill-equipped and unprepared and not ready you are. If not dealt with properly, we will internalize this and think that God has no purpose for us. That's nothing but the enemy, trying to interfere and disrupt the power plans that God has for you right now!

The Holy Spirit kept saying that statement until I got it. All in that car on an early morning commute, God whooped me. I'll just share with you some of what He shared with me and prompted me to write down:

"You don't need a husband right now. Everything that I want to do for you, in you, through you, and with you, I can do it alone. Your purpose in this season does not require a husband, but it requires your obedience. And stop comparing your life to others. Yes, a portion of their purpose required for them to be married early. Yours doesn't. Not never, Krystle. Just not right now. I have plans for you. I got you, but right now, I NEED you to be single."

How do you pick yourself up from that? Now I could have taken that correction and turned it into pity and continue to frustrate the plans of God. But I didn't. I made a choice to boldly agree with God. I made a choice to believe that what He was saying was true. And that's how you're reading this book today. No, it wasn't easy, and it definitely wasn't my preference, but I'm grateful.

You have a God planned purpose long before marriage. Just recall the single women in the book. From serving to hosting, building businesses and the

kingdom, and advocating to just simply following Christ and obeying, they all did that without husbands y'all. Even more so, we've only been able to capture one moment in their lives. Like all we've been able to read is just one of their "good days." Truthfully speaking, we all have good days and bad days. But it was more than just a good day. Indeed, it was a #kairosmoment for them.

Not only were they walking in this moment of their purpose, but God opened a particular moment in time for them to do so. You think all these encounters were by happenstance? Nope. Those are the moments that God prepared for us.

For God to do His "best work," everything must be just right. He doesn't risk His plans and purpose for our impatience. His plans for everything are perfect because that's what He is. Every little detail is perfect—even the timing. The timing must be right (according to God's schedule) for His plans to be manifested. Let's find it in the scriptures.

"You will arise and have pity on Zion; it is the time to favor her; the appointed time has come." - Psalm 102:13 (ESV)

"And Jesus said to her, "Woman, what does this have to do with me? My hour has not yet come." - John 2:4 (ESV)

"Jesus said to them, "My time has not yet come, but your time is always here." - John 7:6 (ESV)

"You go up to the feast. I am not going to this feast,

for my time has not yet fully come." - John 7:8 (ESV)

"Now before the Feast of the Passover, when Jesus knew that his hour had come to depart out of this world to the Father, having loved his own who were in the world, he loved them to the end." - John 13:1 (ESV)

"He said to them, "It is not for you to know the times or seasons that the Father has fixed by his own authority." - Acts 1:7 (ESV)

I've always wondered what would have happened if the Messiah would have revealed Himself at a different time. Thank God we'll never need to know!

Your purpose is bigger than your desire. I SAID, YOUR PURPOSE IS BIGGER THAN YOUR DESIRE! It is more significant than anything you can imagine. It's bigger than your marital status and the numbers in your bank account. Your purpose is not just one moment in time. In fact, your purpose and destiny are made up of infinite moments. Every moment has a time, and every moment can potentially bring glory to God. Remember Lydia's introduction to Paul and the Samaritan woman's encounter with Jesus? Those moments were a part of their purpose. The timing was right. The stage was right. All of it was a divine set up.

The world must be ready to receive the ministry and purpose of you, your husband, and your family. That's right. I said what I said. Timing is everything. Every component of your life can give Glory to God, expand the kingdom, and literally change the world. Romans

8:19-23 explains this beautifully:

"¹⁹For the creation waits with eager longing for the revealing of the sons of God. ²⁰For the created was subjected to futility, not willingly, but because of him who subjected it, in hope ²¹that the creation itself will be set free from its bondage to corruption and obtain the freedom of the glory of the children of God. ²²For we know that the whole creation has been groaning together in the pains of childbirth until now. ²³And not only the creation, but we ourselves, who have the firstfruits of the Spirit, groan inwardly as we wait eagerly for adoption as sons, the redemptions of our bodies." (ESV)

Yes, ma'am, your singleness, and your marriage both have purposeful moments that will accomplish the will of God. Your purpose carries a solution for a specific problem of an appointed time. Right now, the world needs the single, unmarried version of you. It needs your story, your ideas, your contributions, your experiences, your truth, and your testimony as an unmarried woman. And then, when the timing is right, and the people and setting are ready, they will need the other parts of you that are yet to be revealed as a wife.

Now when I think about the word "ready," I get excited. I know God has prepared. The people (husband included), places, and things in my future are being processed and being made ready for ME (God's job). Now we are just waiting.

Waiting: This word has gotten such a bad rap in the singles community. I'm not sure why because if we

really quiet ourselves, we will see that waiting is just a part of life. Today alone, I can guarantee you that you have waited on something or someone.

You could have been waiting in line at your favorite coffee shop, waiting on your 9:00am meeting to begin, waiting for your girlfriend to answer that phone call or text message, or waiting on the pot of water to finally boil so you can have a guilt-free plate of spaghetti. You know, come to think of it, you've been waiting since you were conceived…in your mother's womb, waiting to be introduced to the world. Did you realize that even the Lord God waits? Can you fathom that? How does God the Creator, Jehovah Elohim make Himself wait? Even if we understood how, why would He do it? Why would God cause Himself to wait? Well, I guess you'll just have to wait for that answer...because that's not gonna be in this book!

So, since we had that little talk, let's talk about what's really bothering you. Is it that you feel as though you're waiting without a bonafide promise on the other side? Or is it that you've been waiting for so long, you've just become impatient and restless? Could it be that there's an area of your life void of the presence of God, and you are just not satisfied? Whatever your complaint, we must remind ourselves of God's purposes for waiting.

Lamentations 3:25 – "The LORD is good to those who wait for him, to the soul who seeks him." (ESV)

Acts 1:4 – "And while staying with them he ordered them not to depart from Jerusalem, but to wait for the promise of the Father." (ESV)

Isaiah 30:18 – "Therefore, the LORD waits to be gracious to you, and therefore he exalts himself to show mercy to you. For the LORD is a God of justice; blessed are all those who wait for him." (ESV)

There was a popular meme floating around that I'm sure you have seen. It reads as such:

*Joseph **waited** 13 years.*
*Abraham **waited** 25 years.*
*Moses **waited** for 40 years.*
*Jesus **waited** 30 years.*

If God is making you wait, you're in good company.

I would submit to you, not only are you in good company, but most importantly, you're in the will of God. It's not even that God is making us wait. No, let's reframe that. God is allowing us to wait and remain. Have you ever gone to bake some cookie dough and didn't feel like waiting so you took them out early? I'll say yes for the both of us. Aren't you even that much hungrier, frustrated, and just about willingly to "eat them anyway" because you just don't want to wait? Now you and I both know that cookie is either still frozen and rock hard, or it's too hot and a gooey mess. Sis, you didn't have to rush the process.

When you find yourself getting impatient with waiting, tell your flesh to chill. You don't just want anything when it comes to your purpose. You want what's good, what's right, and what is tailor-made for you.

Well, that's what I think about when I consider that God is allowing our waiting season. Sure, we can go "get" whatever it is we are waiting on. Burger King already told us we can have it our way. But how disappointed would you really be realizing that you should have waited because there were no preparations made and nothing was ready for you?

When we honor that God allows us to wait, we train our minds to know that as our Father, waiting is a means of protection, maturation, and fullness of joy. Allowing us to wait is how we are granted access to that appointed moment.

When I searched for the quote about waiting, I found several more share-worthy quotes for your consideration:

"To us, waiting is wasting. To God, waiting is working." – *Louie Giglio*

I like this quote because we must know that God is always orchestrating things behind the scenes. I had to learn how to thank and praise God for the things that I can't see. Like the song says, "...even when we don't see it, He is working and even when we don't feel it, He's working." He never stops working. I'd like to submit that if you are waiting, God is working. Thus, when we stop waiting and do it ourselves, God stops working on our behalf.

And finally, this is a mash-up from a meme I found mixed with my words.

"Waiting is not just something we have to do until we get what we want. Waiting is the process of giving God what He wants."

No, our God is not some sinister character that likes to make His people suffer. But He does want something from us. He wants our hearts which look like a complete surrender to Him. He wants us to love Him. He wants us to know Him. He wants us to trust Him. He wants us to abide in Him. Years ago, I had learned that to wait for means to tarry. I never really studied this word, or if I did, I simply forgot. So, I went back to something I thought I knew and asked God to show me something different that I had never seen before.

I found out that tarry is not "just" waiting, but there are many distinct definitions for the word. To tarry means to abide, to continue, endure, abide still, abode, to spend time, to be slow, to make it sit down, to be about, and finally to expect and await. All in all, God wants us to simply abide. He wants us to be with Him more than anything else. Anything.

What do you get from these words? Take a moment and jot it down here before continuing:

NO MORE SHAME

You do know that there's nothing wrong with you, right?

Let me say it like this: There is absolutely, positively, nothing wrong with you. Singleness is not a defect. It is not a curse. Neither is it God's rejection of you. Unfortunately, our society and cultures have created an idol out of weddings, Boaz, and marriage.

However, our God is so strategic in His plans for us, He created an appointed time for all those plans to happen. If you take a moment to reflect and then chronicle a timeline of your life, you will see how God has been working His plans for you since the beginning. This includes the moment you were born, the moment you were born again, the moment you excelled, got derailed and failed, and everything else in between. Yes, sis, God has ALWAYS been at work in your life!

Over the years, I've come to know and believe that God's timing is impeccable. You see, the Bible tells us that His plans are not our plans (Jer. 29:11). The Bible also tells us that we can make plans, but God will be the one to establish those plans on Earth.

Sometimes we forget that God has plans for the Earth, and we also forget that He plans to use us (if we let Him) to fulfill those plans on the Earth. What an honor! Let me be frank…it doesn't always feel like an honor. Sometimes it feels like a curse, but today I break that off you! We do not have a God that curses His

own. What kind of Father would that make Him? No. We have a Father who knows us and knows what He has put inside us and knows what we need. This tells us God will always have a bigger vision and purpose for us than what we think or desire. In fact, His vision for us also has a perfect time.

I honestly don't even know how many times I've cried myself to sleep because of the weight of waiting. I don't know how many times I've secretly hated God for making me invisible to men. I don't know how many times I questioned God's judgment (and the condition of my own heart) when I saw other women I deemed "not wife material" meet, date/court, and marry GREAT MEN OF GOD! I just don't know. I stopped counting years ago. But here's what I do know: God's timing is impeccable.

As I'm writing this book, I am single. Really single. There are no prospects in sight and no plan B's on the side. If I had my way, your girl would have been happily married, living a fabulously abundant life with the hubs, and I would have been writing this book poolside in Jamaica or someplace fancy! But I'm not. I'm right where you are. And guess what? God is still using me. Being married would not have made this book any more special than it already is. Yes, it would have made it different and introduced a new perspective, but then it would not be the story and words you and I needed to hear. Beloved, we have to remember these are the plans of God. I wanted to abandon and probably even abort this book if I'm honest. The level of anxiety that has stopped my pen from flowing was deplorable. Without realizing it, I was

subconsciously telling God no to His plan for my life because of what I later discovered was a shame in being single. I had to write this book to be set free from this stigma of "single shaming." As you read it, I hope that you too can find no shame in your season of singleness. That's whether you are single, never married, single because of divorce or death, single until you're in your 50's or beyond, or single until you leave this world. If any of these are a part of God's plan, believe with all your heart that being in His will is indeed what is best for us. There is so much fulfillment, contentment, satisfaction, and pure joy in being in God's will.

I've had to learn not to fake contentment anymore. How did I fake it, you ask?? Let me tell ya! I used to brace myself for disappointment. Yeah, that part. For the longest, an area in my heart just didn't trust or believe God wanted marriage for me. So even though there were suitors and seasons of dating and even a couple of serious marriage focused relationships, I always felt that somehow things wouldn't work out and I'd be starting over again.

You know what I mean, don't you? I'm sure you do. That moment when you meet a guy, things are going well, you pray and believe you've got a green light to proceed, your feelings grow, and you can actually see yourself marrying this man, and then boom, whatever it is, something happens that can't be fixed. Then you take some time to reflect and heal, and the cycle starts all over again. Hopefully, you have been doing this, but if not, begin today.

It is at this moment where the thoughts of defeat

and disappointment would try to overtake me once again. I was so sick of this cycle, but I could not seem to shake it. One day as I was driving to work (yes again…there's something about my car moments with God), the conviction of the Holy Spirit hit me like a ton of bricks. Over the years, I had become extremely bitter and mad and wary of God because of my wait. It was like being the kid in class that knew the answer, but the teacher kept calling on the other students before you. I mean, the teacher even called on those whose hands were not raised! I lived in seasons that felt like years and really decades of God calling on everyone but me.

I became frustrated because I knew the answer! I had studied. I had done the work of healing and unlearning toxic behaviors. I had served in the church…faithfully. I went to the conferences, read books, and bought t-shirts. I had waited faithfully. I sowed into and blessed marriages, I mean really sowed. I even yielded to God to start businesses in the wedding industry to deliberately bless those married before me. Yes, I hadn't realized it before, but the same list I offered to God about the type of husband I desired was the same list of reasons why I felt like He not only "owed" me a husband within the parameters of my timeline. This was laughable.

So, driving to work one day, I knew it was God when I heard Him say, "Don't curse this season."

Have you been there before? Or maybe I should ask, when was the last time you were there? Beloved, I know you know this, but I'm going to say it anyway: That place in our hearts and thinking needs repentance and

cleansing. Even after hearing the warning of the Lord, I struggled between the years to remember not to curse this season. I had to tell myself that even though I am single, I am living my best life!

It wasn't until sometime later when I realized that the God we serve just isn't a checkbox kind of God. I wanted to do the things that would guarantee me a husband versus the things that would guarantee me real intimacy and fellowship with God, my Father. Don't get me wrong, sometimes my heart was right and pure in doing these things, and then there were times where my heart was merely compliant and begrudged. I was tired of doing and not feeling like there was a return on my investment. If you are in that place now, can I share a hard lesson with you? We're not loving, serving, and living in Christ to get anything. God owes us nothing. After salvation, we have everything needed to satisfy and sustain us. We continue loving, serving, and living in Christ so that we can go deeper.

There's so much more to God than what our mortal man can comprehend or fathom. I'm not saying the desire for marriage is surface or carnal; I'm purely saying that there's more to search and seek out in Christ. I think Apostle Paul communicated this beautifully in his letter to the church of Ephesus. It reads:

When I think of all this, I, Paul, a prisoner of Christ Jesus for the benefit of you Gentiles . . . [2]assuming, by the way, that you know God gave me the special responsibility of extending his grace to you Gentiles. [3]As I briefly wrote earlier, God himself revealed his mysterious plan to me. [4]As you read what

I have written, you will understand my insight into this plan regarding Christ. ⁵God did not reveal it to previous generations, but now by his Spirit he has revealed it to his holy apostles and prophets. ⁶And this is God's plan: Both Gentiles and Jews who believe the Good News share equally in the riches inherited by God's children. Both are part of the same body, and both enjoy the promise of blessings because they belong to Christ Jesus. ⁷By God's grace and mighty power, I have been given the privilege of serving him by spreading this Good News.

⁸Though I am the least deserving of all God's people, he graciously gave me the privilege of telling the Gentiles about the endless treasures available to them in Christ. ⁹I was chosen to explain to everyone this mysterious plan that God, the Creator of all things, had kept secret from the beginning. ¹⁰God's purpose in all this was to use the church to display his wisdom in its rich variety to all the unseen rulers and authorities in the heavenly places. ¹¹This was his eternal plan, which he carried out through Christ Jesus our Lord. ¹²Because of Christ and our faith in him, we can now come boldly and confidently into God's presence. ¹³So please don't lose heart because of my trials here. I am suffering for you, so you should feel honored. ¹⁴When I think of all this, I fall to my knees and pray to the Father, ¹⁵the Creator of everything in Heaven and on Earth. ¹⁶I pray that from his glorious, unlimited resources he will empower you with inner strength through his Spirit. ¹⁷Then Christ will make his home in your hearts as you trust in him. Your roots will grow down into God's love and keep you strong. ¹⁸And may you have the power to understand, as all

God's people should, how wide, how long, how high, and how deep his love is. [19]May you experience the love of Christ, though it is too great to understand fully. Then you will be made complete with all the fullness of life and power that comes from God. [20]Now all glory to God, who is able, through his mighty power at work within us, to accomplish infinitely more than we might ask or think. [21]Glory to him in the church and in Christ Jesus through all generations forever and ever! Amen. (Ephesians 3:1-21, NLT)

To my sisters who have been doing the right stuff and still waiting, I want to encourage you to go deeper in God. Not to accelerate or expedite your waiting season, but so that you will be made complete with all the fullness of life and power that comes from God. This is what this book was all about. Do more of the things that fill your life and the things that give you power.

Except for Esther, we never hear the unmarried women's full stories as it relates to if and when they marry. All the others pretty much go on living their lives. Some were married, but that's not what is mentioned in their biblical stories. My prayer is that your life would be so full that there's more to your story than "just being" someone's wife. While praying for you, I couldn't help but to thank God for the women that contributed to this book. I'm not talking about supporters and friends. I'm talking about each of the women I've presented in this project. Yes, Biblical characters were actual real people! I thanked God for them, because had they not said yes to God in their singleness, we wouldn't have their example to glean

from today.

Imagine that. What if the Bible is still being written? What if your life lived as a single woman encourages, heals, and delivers a new generation of women you'll never meet? It's possible. My prayer is that your tales of sisterhood, obedience, service to your community and others, prosperity in health and wealth, innovations and inventions, spiritual motherhood, and more would also be written about you. There's more in your singleness than you know. Let God get the most out of you while you are completely His. It's all going to be worth it. Amen.

Worship
"Face to Face" - *by Janice Gaines*

Prayer

Dear Lord,

Use my story to bring you glory. I trust you.

In Jesus' Name, Amen.

10 SINGLE LADY RESOURCES

Most people look at life and see nothing good, nothing to report, nothing to write home about. Others see life and have concluded that the best of it was 20, 30, 40, and 50 years ago. Some people may view life and see prison walls, dark dungeons, and homeless streets. Literally and figuratively.

As much as we love it or loathe it, life was a gift given to all of us. We never even asked for it. We didn't get to meet our parents before our birthdays and beg and plead for conception. Our life was and is a part of a more excellent plan beyond what we could ever ask or think.

I just learned something, something that I knew all along. Our God is a master creative writer; our God creates. He has created. And He is creating. One thing that we cannot deny about life is that GOD WANTS us to enjoy life and live it abundantly. (John 10:10)

One undeniable life question that all have and will

ask is, "Does anybody love me?" and "Who can I love?" Typically, this answer starts the same way with everyone. My family. My friends. My Creator. Then sometimes, the answers will become more specific. We hope to identify with at least one person as loved by. This season's expressions of love come from many different stages in our lives. It could be from a parent's love, sibling love, friendship love, and romantic love. Albeit standard to have a love of your friends and family, I realized that a key to surviving is thriving. Other words for thriving are flourishing, prospering, succeeding, blooming, blossoming, increasing, and growing well.

While we are young, we tend to become discontented with this "thriving" process. It appears the grass IS, in fact, greener in everyone else's life. We assume that struggles and hardships don't come attached to our perfected ideal of life. Sometimes we forget that trouble doesn't discriminate, the struggle has no favorites, and disappointment is friends with EVERYBODY. It's okay. I'm guilty too. However, I've come to learn that if I'm going to live a thriving life (flourishing, prospering, succeeding, blooming, blossoming, etc.), then I've got to be placed in a position to accept and receive growth.

If we are to grow, we've got to connect ourselves to things - and people that are growing. Moreover, you've got to connect to people that are thriving in Christ.

I like to use the imagery of flowers and weeds. Flowers are the seed-bearing part of a plant. They are typically identified by beautiful colors, fragrances, and

human value. Flowers carry the reproductive organs of a plant. This value comes from its quality to reproduce. Weeds, however, are the stray seeds from something that was not intended to grow. A weed is a wild plant growing where it is not wanted and in competition with cultivated plants.

Think back to springtime. When was the last time you saw weeds with flowers? It is sporadic to see flowers and weeds together. Most weeds are immediately plucked from the field to ensure that they don't destroy the flowers.

The point that I'm making is that if you want to blossom and succeed and thrive, you must surround yourself with a field of mature flowers. If you've ever been inside of a florist's cooler, you'll notice that the flowers are organized in like groups—Roses with roses, carnations with carnations, tulips with tulips, and so on. Take note of this and model yourself as such. If I want to be a rose, then with the roses I'll hang. If my heart's desire is to bloom as the tulips, then the tulips have become my new best friends. True, I may be a seed right now, but we all have a starting point. Simply put, surround yourself with the images, words, mannerisms, and characteristics of the type of woman you want to be.

One way that we can do this is by praying for mentors and biblical examples of exemplary women. This is the focus or outline of this book.

When Jesus was preparing to be crucified, He spoke these words to his disciples. In John 12:35-36, He said:

35Then Jesus told them, "You are going to have the light just a little while longer. Walk while you have the light, before darkness overtakes you. Whoever walks in the dark does not know where they are going. 36Believe in the light while you have the light, so that you may become children of light." When he had finished speaking, Jesus left and hid himself from them. (NIV)

This is an example of how we should seek out what I like to call "lightbearers." Lightbearers are the everyday examples of people we can relate to that carry the wisdom, grace, knowledge, mind, and heart of Christ. This may be a relative, church member, neighbor, friend, or a biblical figure. Before writing this book, I completed a discipleship small group with my church and another ministry. In this small group, we came across a positively life-changing lesson. This lesson, in its purest form, challenged years of wrong thinking. It caught me off guard. I remember looking at the page's header and thinking, *this is going to be way over my head.* I was dreading this topic because I knew it would be redundant, over-spiritualized, and daunting and leave me feeling like the "Queen Sinner." I was never so wrong in all my life. This lesson opened the door of my hurting heart and empowered me to accept God's heart of hope.

The Attributes of God. That was the two or three-week lesson in Dave Buehring's book, *A Discipleship Journey.* By the end of our year-long study, we were still learning and soaking up the love and freedom we studied in this chapter. In this study, John 10:10 came alive; it leaped

off the pages of my pink NIV Bible and met me in my bedroom, office, mall, car, church, or wherever. Life was illuminated.

I share this story with you because you will most definitely need to prioritize an "Attributes of God" study season in your life if you haven't already. I would urge you to complete this study with a small group and/or spiritual leader. This is the type of investigation the enemy will fight because your knowledge and revelation of Jesus Christ is a threat to the Kingdom of Darkness. Find friends and family who will commit to studying with you. This lesson opened the doors of my hurting heart to receive timely healing.

Hopefully, as you have come to the end of this book, you have been encouraged, empowered, and equipped to live a single life of purpose, holiness, and success. In the years that it took me to write this book, God had to show me how to do life with Him. In the moments when I was lonely, lost, hopeless, and frustrated, He taught me how to love Him and focus on the things that mattered at that moment in time. He showed me that a husband will come for me at the right time, but this timing (the timing I was in) was for another portion of my purpose and destiny. Even though I heard what God said, I repeatedly prayed for help. I asked for resources in the form of books, seminars, counsel, right relationships, strength, and more. Just like the amazing Father that God is…. He supplied that and more. I have compiled lists of books I read, songs I worshipped to and podcasts that have kept me sane. None of these lists are exhaustive, but they are great resources to begin with. I hope you find something in these lists that will

help you today and even up to the day you cross over into a new season of purpose.

RESOURCES FOR SINGLE LADIES

The party is not over yet, ladies. There's an entire webpage of resources as you journey through your single season. Check out the link below to get your FREE Single Lady resources.

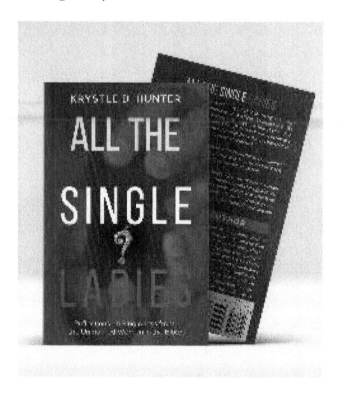

Visit www.kairoskrystle.com to connect with me! I'd love to hear which #SingleLady resonated the most with you.

ACKNOWLEDGMENTS

God-- Lord, it literally could not have been done without you. Thank you for the late nights, early morning, and long car rides. Thank you for the push. Thank you for my single season. I didn't see this coming, but you've been there through it all, and you kept your word. I love you.

My Family-- I am here today because God gifted me with you! Your love is unmatched and I'm grateful that you have always made me believe that I was somebody special. Thank you for loving me first!

Pastor T-- Tears. Gosh, how do you do it? You have NEVER given up on me. You have NEVER made me feel less than. You have NEVER allowed me to be less than what God made me. Thank you. You're my Naomi forever. You and Pastor Holland introduced me to a facet of God I have NEVER known before, and my life hasn't been the same since. Thank you forever.

Pastor P, Lady P & Restoring Faith Ministries-- Thank you for your covering, love and support like no other. You speak life, stir up the gift and encourage me to press on and please God above all else. Thank you.

Godmommy Pastor Theda-- You literally saw my process up close and personal. But you are my Mordecai. One of my gatekeepers that wouldn't let my own self get in the way of what God was doing and will

continue to do. You didn't go through all of it for nothing. It was for me. Thank you for taking me in, under, over, and through.

Raynika-- Ray, I watched you do it first. You were the first to offer assistance. Year after year, you checked in and encouraged me. Without judgment, you allowed God to work it out of me and taught me to pray before anything. That's how this was accomplished, and I will always be grateful to have shared this experience with you.

Sherry-- I've never met a silence that pierced my life as yours does. Your silent words were a balm for my sickness of doubt and insecurity. Thank you for believing in me. Without question, you have prayed for and sowed into this baby as if it were your own. Who does that? Sherry does. You are one of my Marys, so thank you for causing my baby to leap!

To ALL my Sisterfriends-- You all know who you are. Thank you for allowing me to go through the process. Unbeknownst to you, you helped me push this through. Thank you, Sis. I love you.

ABOUT THE AUTHOR

Krystle D. Hunter is a dynamic leader, serving youth, women and families across the nation and abroad. She's a lover of laughter, sisterhood and seeing people win. As an ordained minister, Krystle shares her love for empowering and celebrating women through mentoring, facilitation, discipleship and social connectedness events. She wholeheartedly believes, every life can be enriched and transformed by developing an authentic relationship with Jesus Christ. Learn more at www.kairoskrystle.com

All the Single Ladies

Printed by BoD™in Norderstedt, Germany